SEVENTIES SPOTTING DAYS AROUND THE WESTERN REGION

SEVENTIES SPOTTING DAYS AROUND THE WESTERN REGION

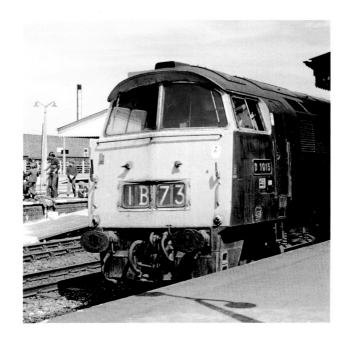

Kevin Derrick

AMBERLEY

First published 2016

Amberley Publishing
The Hill, Stroud
Gloucestershire, GL5 4EP

www.amberley-books.com

ISBN 978 1 4456 6089 9 (print)
ISBN 978 1 4456 6090 5 (ebook)

British Library Cataloguing in Publication Data.
A catalogue record for this book is available from
the British Library.

Typesetting by Amberley Publishing.
Printed in the UK.

Contents

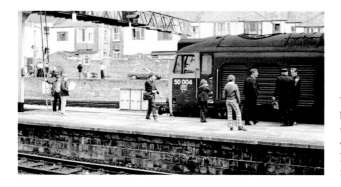

With a pair of trousers that would be outrageous even on a golf course today, one of this group of spotters watches on as the crew changes on No. 50004 at Plymouth in April 1976. (Stuart Broughton)

Introduction

In this the first volume of *Seventies Spotting Days*, we take a journey around the Western Region and back along memory lane. The region's management had set themselves apart during the 1955 Modernisation Plan by adopting hydraulic transmission for their diesels. The first of these were set aside as early as 1967 and within the following decade they would all be gone. As further closures of lines and goods services progressed into the seventies, more and more Classes 25, 31, 37 and 50s would become available to the Western Region, the latter displaced from the London Midland Region as the electrification progressed along the WCML. However, that is another story, covered in a companion volume. As the decade commenced Warships, Hymeks and the troublesome North British locomotives were still being repaired at Swindon, as were of course the Westerns. Then it seemed that time had flicked back ten years again as the works yard began to fill first of all with dumped hydraulics, then as these were being cleared they would be joined by ranks of Classes 24 and 25 cascaded down from as far away as Scotland.

Change was of course happening all across the country, with the trials first of all of the High Speed Train prototype followed by the speedy introduction of shiny new HSTs to the top flight services of the Western Region, meaning that even the still relatively new Class 50s and even 47s would hasten the demise of the last few Hymeks and Westerns. The spread of car ownership and the progressive swing towards road transport and heavy goods vehicles left the railways in a poorer state for both enthusiasts and the country by the end of the seventies.

Many photographers of the sixties had hung up their cameras at the end of steam in 1968. It seems that it was the culling of the Class 52 Westerns that brought many back to the hobby, influenced by scenes of carnage from the cutters at Swindon. Indeed your author dropped the ball, as it were, for a while in the seventies, being of the age to legally discover wine, women and song. I suspect many readers will share similar experiences of suddenly discovering that it seemed our beloved Westerns were being withdrawn almost wholesale, and quickly found ways of slotting in our older hobbies with new experiences and starting work. For older readers I must beg your indulgence as perhaps your teenage years were in the previous decade or the fifties. As in the books in the *Sixties Spotting Days* series, we will also remember various details from the time, whether they be musical, sporting, recreational, fashion, television, radio or news headlines to help us place those seventies spotting days once again.

As the icons of the 1960s are fondly recalled by one generation, I am sure so many of us will recall the 1970s again with a wry smile for the flares, haircuts, glam rock, three day weeks, strikes, power cuts and rampant inflation to name but a few. In the series we will remind ourselves of some of the other everyday features of life of the times when the photographers took their shots. If you would like to join the growing band of photographers who would like to see something done with their collections rather than let them grow old and dusty in a cupboard somewhere, then do get in touch. Meanwhile, sit back in your favourite armchair with some music from the seventies on in the background and join me for a wallow in nostalgia.

Kevin Derrick
Boat of Garten

Catching the attention of a few spotters at Bristol Temple Meads on Saturday 30 March 1974 was the sound of D1008 *Western Harrier* as it passed through. A few months later in August this locomotive was involved in a minor collision, which once would have meant a trip to Swindon for repairs, but by 1974 it was not to be and it was withdrawn officially by 21 October that year. By the time Rod Stewart had been knocked off the number one spot with 'Sailing' in early October 1975, the cutters had completed their work at Swindon Works. (Roger Bradley)

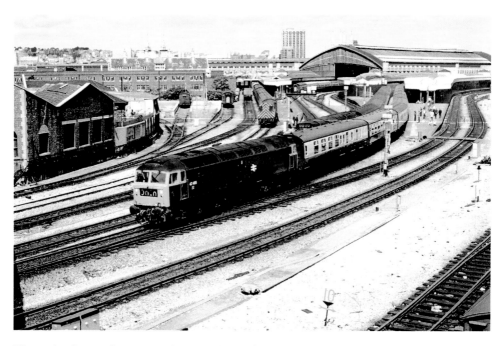

The usual gathering of spotters can be seen at the platform ends as No. 47485 gets away from Temple Meads in June 1976. This Bristol-allocated Class 47 had been renumbered from 1683 in December 1973, the D prefix having been dropped a while before. (Roger Griffiths)

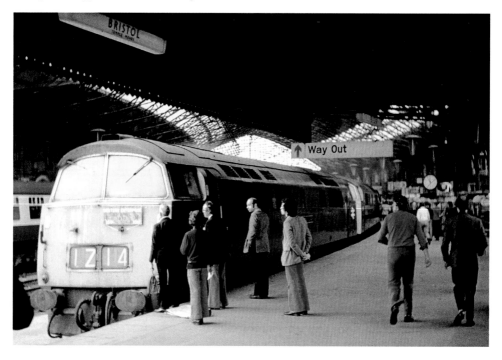

Again, trousers of the time greet D1023 *Western Fusilier* and D1051 *Western Ambassador* within Temple Meads on 27 April 1975. The tour *Western Enterprise*, having arrived from Paddington, would return via Gloucester, New Street and Oxford to the capital. (John Green)

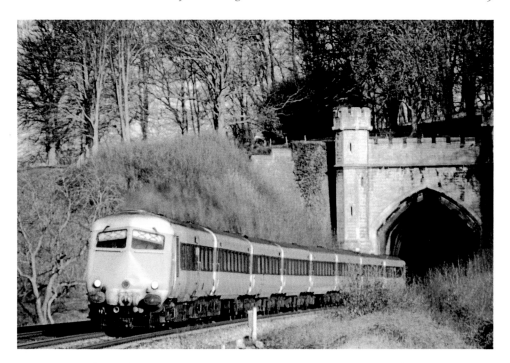

Running out of Twerton Tunnel into the setting sun is the eight-car Bristol Pullman for the last service on 4 May 1973. Having departed Paddington at 16.45, the service arrived at Bristol around 18.40. (Roger Griffiths)

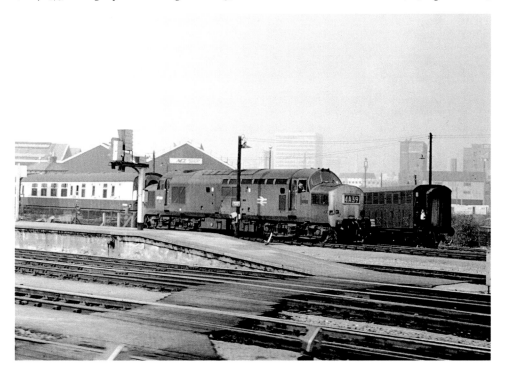

Showing signs of where the old number 6969 had been painted out during the previous month was Landore-based No. 37269 during shunting operations at Temple Meads on 30 March 1974. (Roger Bradley)

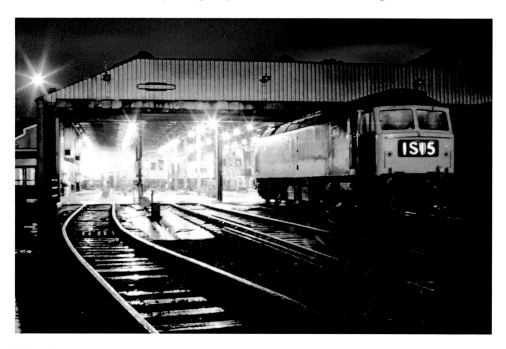

When this early evening shot was taken at Bath Road during 1972, the depot was still coded as 82A. When the new alpha depot codes came into use on 6 March 1973, all of the depot's locomotives would receive stickers showing the new code of BR. (Roger Griffiths)

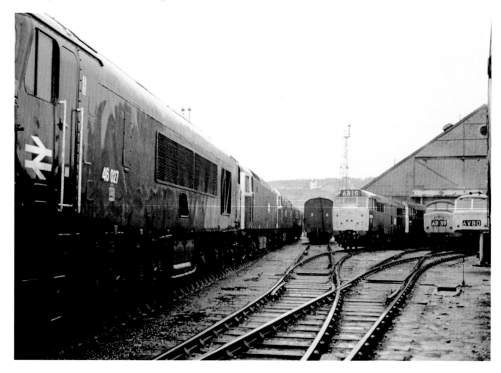

Walking up and down the lines on this damp 1974 day, one of the last surviving Hymeks can be seen in among the sea of blue renumbered locomotives at the back of Bath Road depot. (Roger Griffiths)

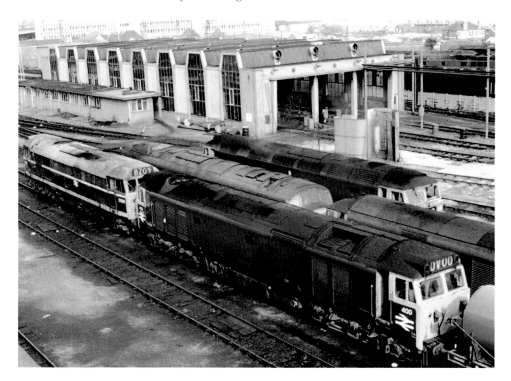

Seen on the first day after arriving from the London Midland Region in October 1972 was 400, still wearing the leasing plate from English Electric along the engine's flanks. Two days later the very first episode of 'Emmerdale Farm' went to air on television. (Richard Griffiths)

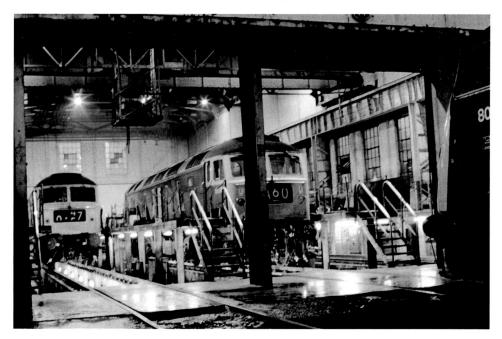

Taken just a few days before 806 *Cambrian* was withdrawn from service at the beginning of November 1972, was this view into the depot at Bath Road with a pair of Class 47s being serviced between duties. (Richard Griffiths)

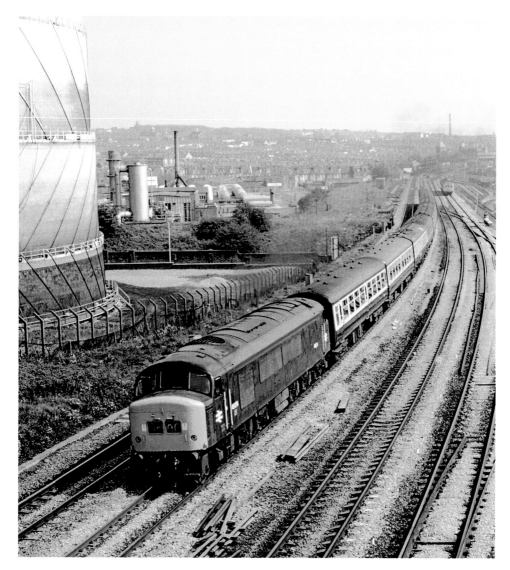

Much of the nation had undergone conversion to North Sea Gas from Town Gas when this photograph of No. 45074 passing the old gas works at Narrow Hills Junction was taken in May 1976. The same month had seen a real David versus Goliath contest in the FA Cup, with Southampton beating Manchester United 1-0 at Wembley to win the FA Cup. (Roger Griffiths)

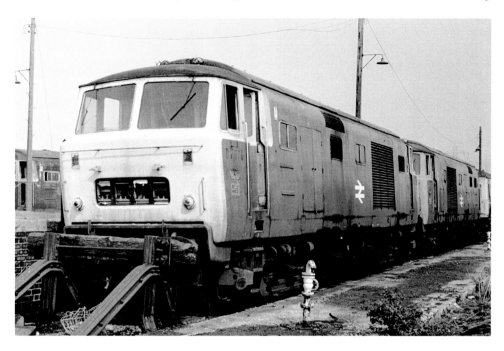

A visit to Marsh Junction on 30 March 1974 found a number of withdrawn Hymeks in store, all stripped of their metal numbers and headcode blinds by souvenir hunters. Among them was D7076, withdrawn on 6 May the previous year. This engine would remain on British Rail's books until eventually sold into preservation early in 1983. (Roger Bradley)

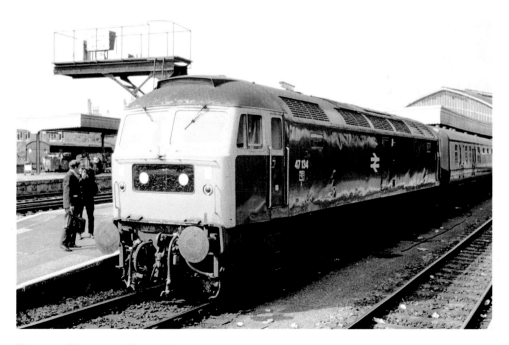

This shot of No. 47134 at Temple Meads on 30 August 1979, at the end of our decade, was taken just after the British public had been shocked by the troubles in Northern Ireland which had seen the Warrenpoint ambush and an attack on Lord Mountbatten the same day, resulting in twenty-three deaths. (Steve Feltham)

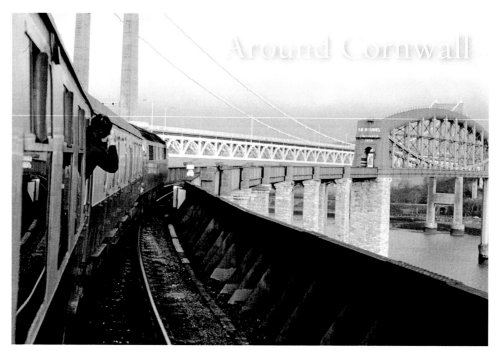

Another cameraman grabs his shot of D1047 *Western Lord* crossing the Royal Albert Bridge on 7 February 1976. This locomotive was withdrawn twenty-one days later, just managing to get in thirteen years' service. (Strathwood Library Collection)

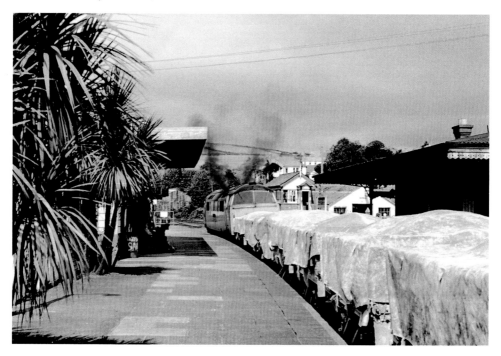

A very Cornish scene in August 1974 at Lostwithiel, with a hard working D1067 *Western Druid* on a rake of clay hoods passing the palms planted at the station which had opened as long ago as 4 May 1859. (Ian Harrison)

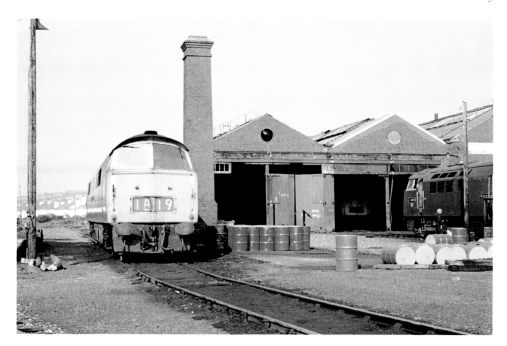

The chimney of the sand-drying furnace at Long Rock Penzance stands proud alongside Westerns D1069 *Western Vanguard*, D1057 *Western Chieftain* and D1007 *Western Talisman* on this visit on 8 September 1973. (Peter Halsall)

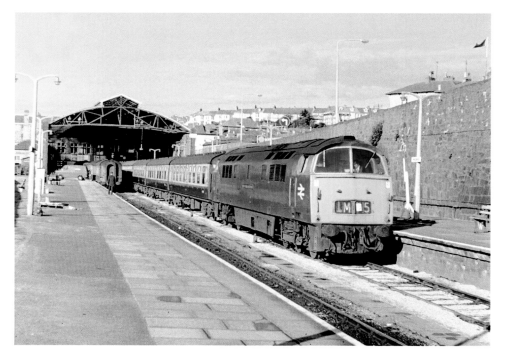

Mail and parcels are exchanged in the background at Penzance station on 6 September two years later in 1975, as D1064 *Western Regent* prepares for departure. Among the big films at the cinema that year was 'One Flew Over the Cuckoo's Nest'. (Ian James)

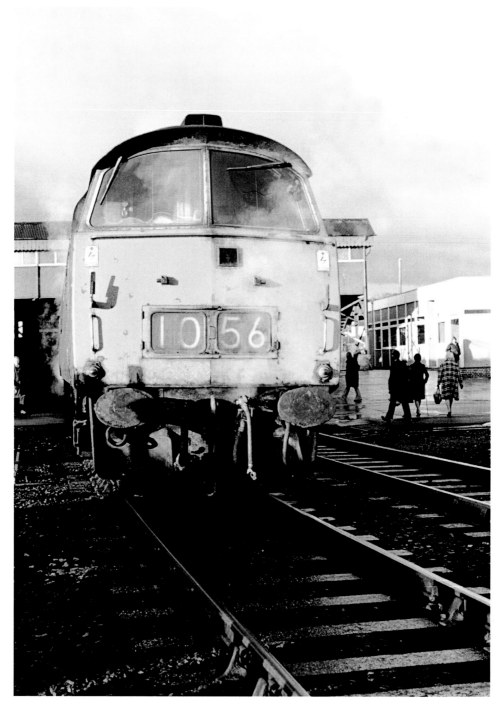

Truro is the only city in the county of Cornwall, and on 4 December 1976 was one of the scheduled stops for the *Western China Clay* tour. Along with D1023 *Western Fusilier* was D1056 *Western Sultan*, seen here, which had worked the Falmouth to Truro leg of this lengthy tour that departed from Paddington at 00.35 that morning, arriving back in London at 20.45. One coach had to be removed from the train at Bristol during a one-hour stop around 3 a.m. with a failure of both lighting and heating! (Strathwood Library Collection)

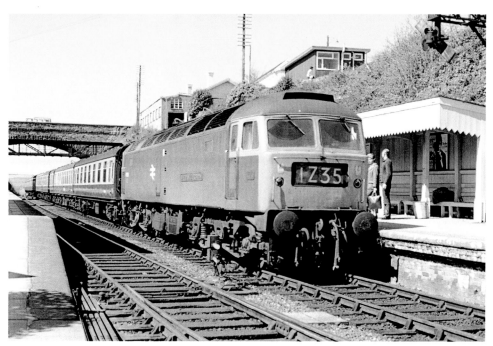

The sun was shining at Liskeard on Easter Monday on 15 April 1974, resulting in an Up relief being run with No. 47078 *Sir Daniel Gooch* at its head. This is the junction station for the branch to Looe. The line ran only from Looe to Moorswater for forty-one years after opening in 1860, until finally being extended to join the Great Western main line in 1901. (Nick Gledhill)

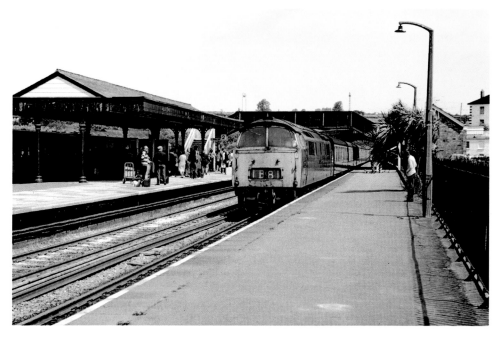

Another junction station on the Cornish main line is at Par, where the line to Newquay diverges. Most spotters would alight here to take the ten-minute walk to St Blazey depot. This visitor, on 5 June 1975, was greeted by D1055 *Western Advocate* for the next stage of his journey. (Ian Harrison)

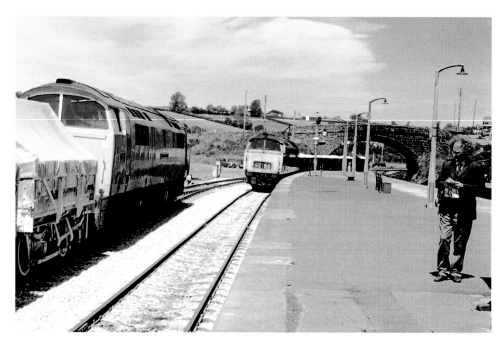

Just as perm hairstyles for men were becoming popular we catch this spotter in action as D1071 *Western Renown* and D1063 *Western Monitor* were about to cross at Par with workings to and from Fowey on 5 June 1975. (Ian Harrison)

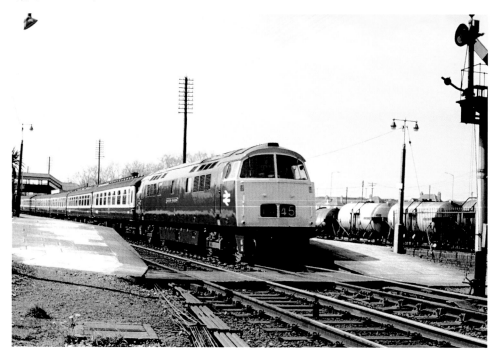

Another visitor the previous year, on 17 April, recorded one of Laira's repainted Westerns, D1034 *Western Dragoon* pulling up at St Erth with the 12.40 from Penzance. Aside from the milk traffic once handled here, this location is also the junction for the branch to St Ives. (Nick Gledhill)

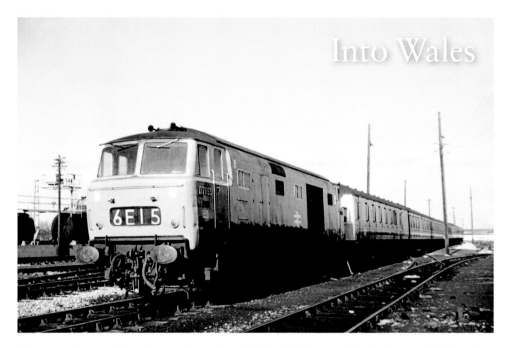

A large contingent of Hymeks were allocated to 86A Cardiff Canton as the decade started. Joining them was D7065, stabled among the DMUs at Canton in 1971. This particular locomotive was taken out of traffic officially on 1 January 1972. (Neil Snuggs)

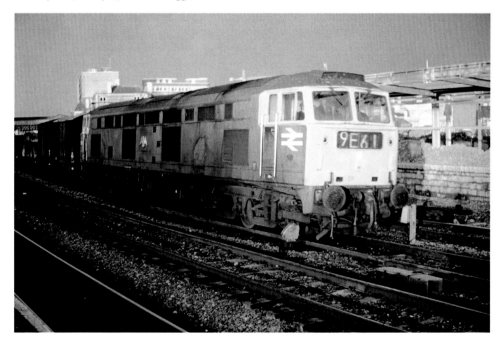

This pleasing view of *Falcon*, renumbered into British Rail stock as 1200 from D0280 on 19 December 1970, appears to have not seen the attentions of a paintbrush since that livery and number change when caught at Newport in October 1974. This favourite had been withdrawn briefly in May that year and would see a further year's action from June 1974, until finally taken out of traffic officially in October 1975. (Arthur Wilson)

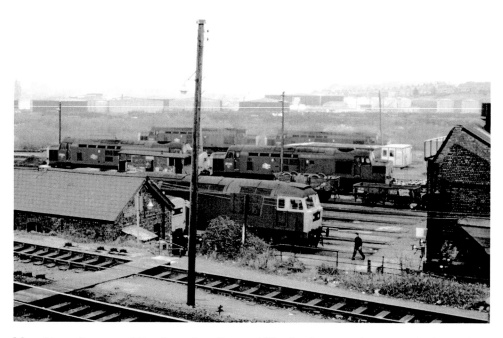

Most visits to the area would involve a trip to Barry and Woodham's scrap yard as seen in the distance here. Perhaps you would find a few engines stabled at the former 88C Barry engine shed which had been closed when steam was withdrawn here in September 1964. Our visitor records a sole 47 among the 37s on Saturday 22 December 1979. (Colin Whitbread)

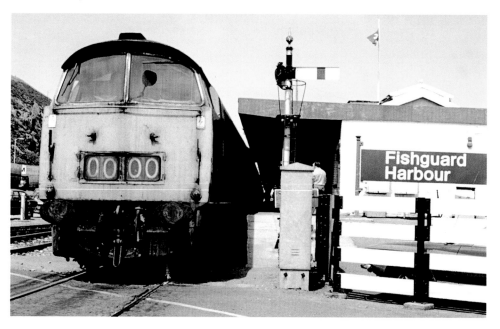

Two hundred and sixty-two miles from Paddington, passengers were able to connect with the ferries to Rosslare in Ireland from Fishguard Harbour. When seen at the terminus here on 26 June 1976, D1001 *Western Pathfinder* would have just another three months before a collision at Stoke Cannon on 3 October 1976 would leave nothing but immediate condemnation the next day. (Strathwood Library Collection)

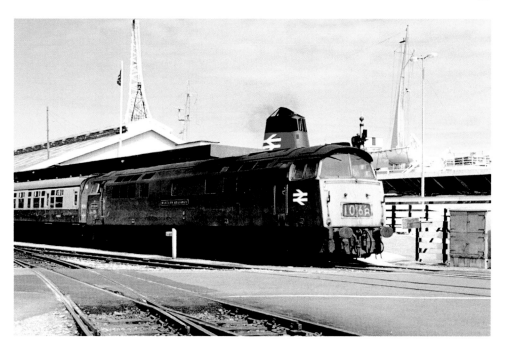

Another visit by the same cameraman on 17 July 1976 rewards us with a view of D1068 *Western Reliance* also a few months away from being taken out of service. This last summer for chasing Westerns had begun with that classic Wimbledon mens' tennis final between Bjorn Borg and Ilie Nastase. It would also be remembered as the long hot summer. (Strathwood Library Collection)

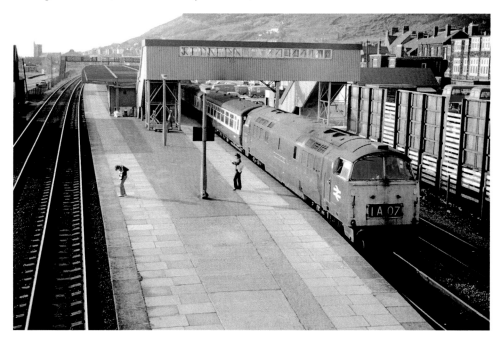

Two spotters record details of D1002 *Western Explorer* at Port Talbot as the driver opens up with the 18.45 service to Paddington on 28 April 1973. One of the most famous sons of Port Talbot was Richard Burton, who had appeared in 'Under Milk Wood' that year. (Frank Hornby)

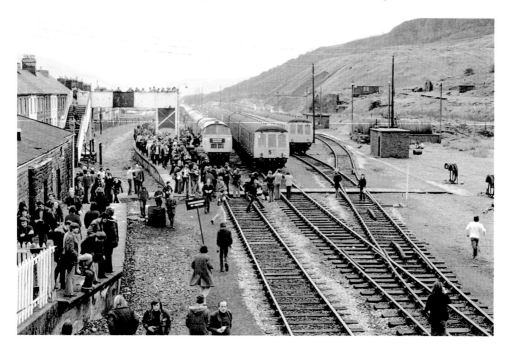

Crowds of enthusiasts have descended on Treherbert station after alighting from the *Western Requiem Relief*, hauled by D1010 *Western Campaigner* throughout from Paddington on 13 February 1977. In those last frantic two weeks of Westerns in traffic, such was the demand that the tour proper was run the following week. (Strathwood Library Collection)

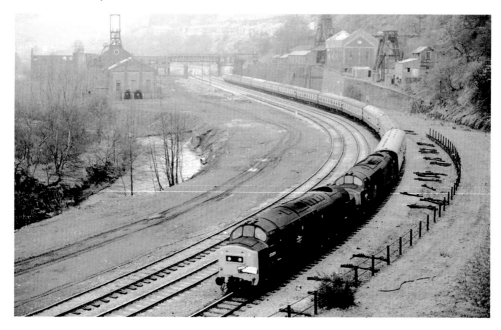

Other casualties of the 1970s were a number of coal mines in the Welsh Valleys, but the pit here at Llanhilleth had already been closed for nine years when Nos 37269 and 37233 brought the 'Gwent Valley Invader' past on 11 March 1978. The photographer had been expecting No. 40120 which had been taken off at Newport and later failed, leaving No. 47001 to take the disappointed tour participants back to Derby. (Roger Griffiths)

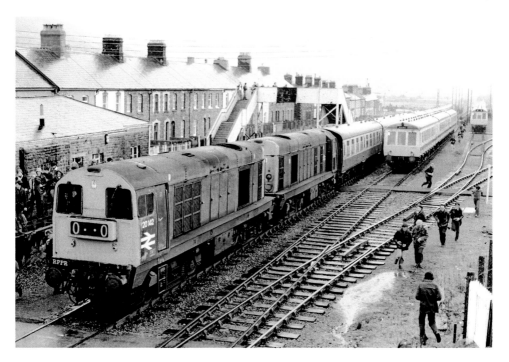

Back to Treherbert at the head of the Rhondda Valley, this time with a brace of Class 20s: Nos 20142 and 20032 which had taken over from No. 55018 *Ballymoss* at Cardiff, having handled the Paddington – Cardiff – Paddington legs of *The Deltic Dragon* tour on a very cold 29 January 1978. (Roger Griffiths)

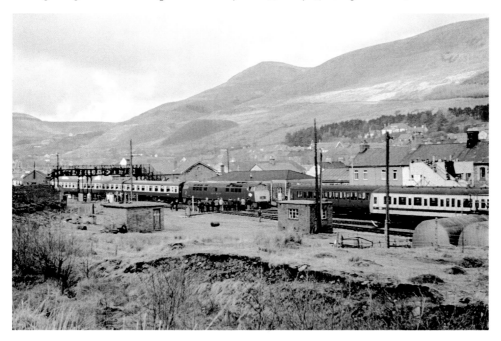

The mixed liveries show up better in this view of the DMUs employed on the local services at Treherbert, with some refurbished and others retaining the plain blue, on Sunday 13 February 1977 when the first *Western Requiem* tour with D1010 *Western Campaigner* had brought so many visitors out for the day. (Colin Whitbread)

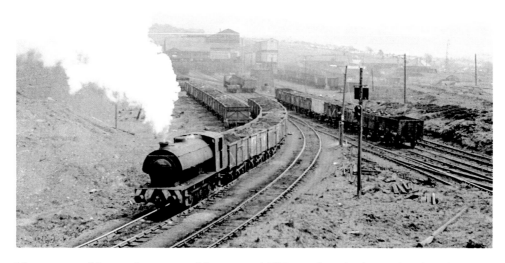

Maesteg was still busy with steam on 5 May 1971, with HE3847 of 1957 hard at work and another in the background. The pit and washery here supplied coal for both domestic use and the hungry steel furnaces of South Wales before finally closing on 22 November 1985 as the last deep pit in the Lynfi Valley. (Stewart Blencowe Collection)

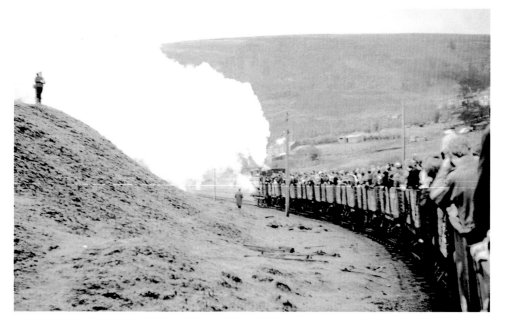

The South Dorset Branch Lines Society organised the 7754 Special for 21 March 1970 to run between Talywain Crossing and Blaenerychan Colliery before the closure of this NCB line. No doubt our chances of such a tour today, with happy enthusiasts packed into open wagons along some fairly suspect track, would raise an eyebrow or two. (Strathwood Library Collection)

Stopping off for Exeter

Catching the sun on 11 June 1975 was D1064 *Western Regent* at Exeter St Davids. A few days earlier, Windsor Davies and Don Estelle had just hit number one in the charts with 'Whispering Grass' which stayed there for three weeks, such was the popularity of 'It Ain't Half Hot Mum' at the time. (Steve Ireland)

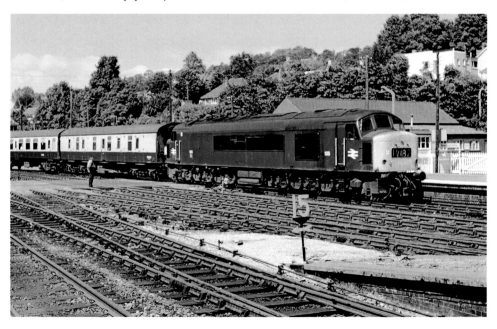

Rolling into the city the previous summer was Class 45 105 which would be renumbered as No. 45064 in January 1975. The station at St Davids had been opened on 1 May 1844 and was designed by Isambard Kingdom Brunel. Much rebuilding took place over the following years from that original two-platform station as the terminus of the Bristol & Exeter Railway. (Arthur Wilson)

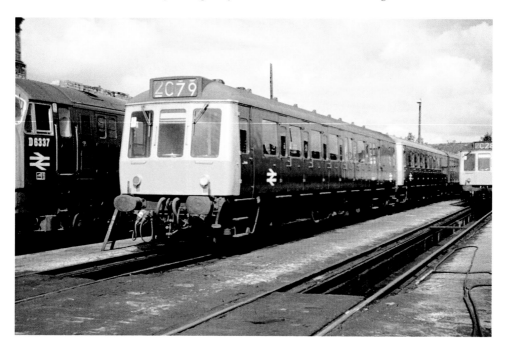

The site of the former engine shed opposite Exeter St Davids station, coded 83C in steam days, was closed officially on 14 October 1963, although as this view shows it was retained in use for stabling both locomotives and DMUs throughout the seventies. This view from the beginning of the decade shows several units, along with a North-British-built Class 22 in its last few months of duty. (John Ferneyhaugh)

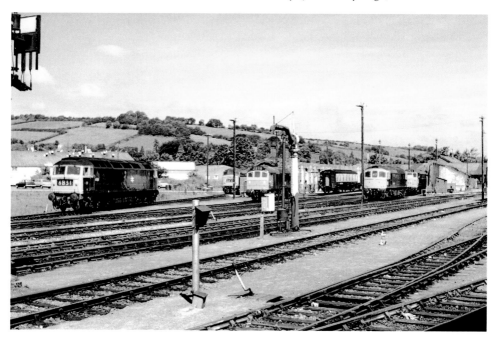

The second view taken in July 1974 shows that things had changed rolling stock wise with the Class 25 and Class 31 ousting the hydraulics. The coach had been taken off the Penzance to Paddington sleeper service. The trappings of the steam age remained with the now defunct water column. (Arthur Wilson)

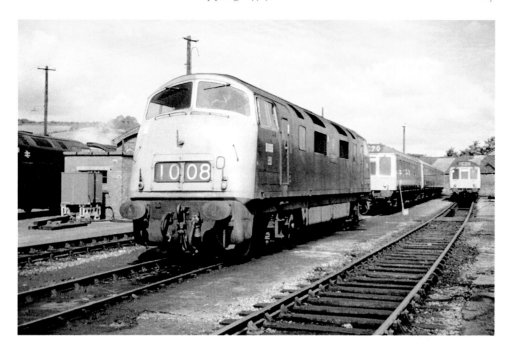

One of the few remaining Warships still in maroon by 1970 was D806 *Cambrian*, repainted into blue during a works visit in early March 1971 – we have already glimpsed this machine at Bath Road. Delivered along with D807 *Caradoc*, the pair entered traffic in June 1959 based at Laira. (John Ferneyhaugh)

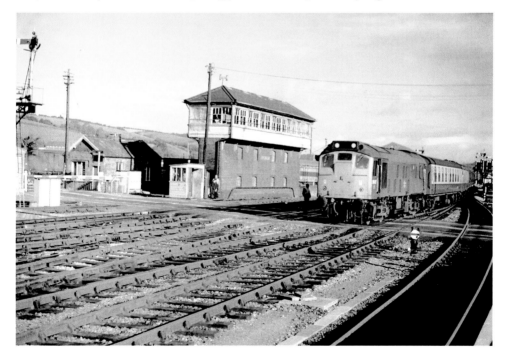

Starting its career at Toton in June 1963 as D5207 was No. 25057 seen here in September 1978. This locomotive had only come to Laira and the Western Region that May and would move back to its native London Midland Region and Longsight in November the following year. (Ian Harrison)

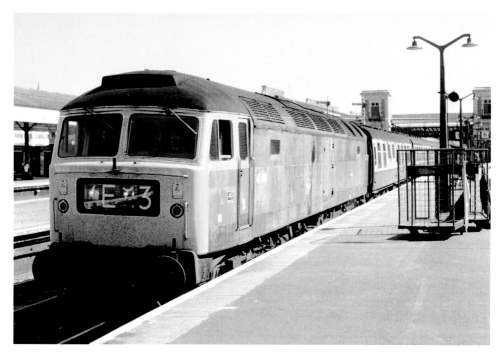

Looking the worse for wear by the early summer of 1974 was the erstwhile D1677 *Thor*, renumbered that March as No. 47091. The headcode blinds no longer appear to be serving much use although the lights shine brightly. (Arthur Wilson)

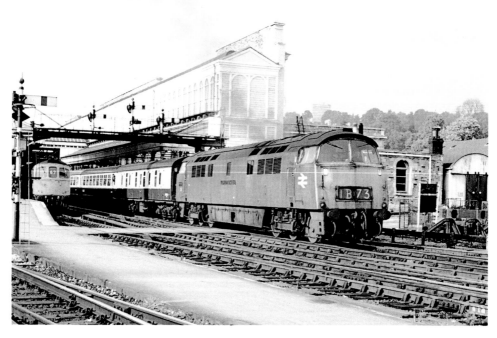

Another case of a shabby paint job worn by D1063 *Western Monitor* the same year on 25 May 1974. Originally painted into blue in October 1968, this engine never had a Laira repaint. (Strathwood Library Collection)

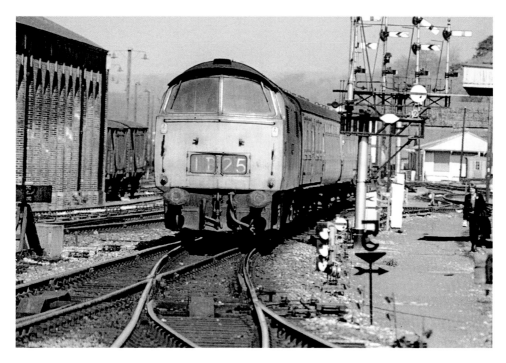

Rolling into Exeter St Davids on 16 April 1974 was D1061 *Western Envoy*. This Western would go into store as of 5 August a few months later and then to Swindon Works that November, to be cut up by the end of the summer of 1975. (Nick Gledhill)

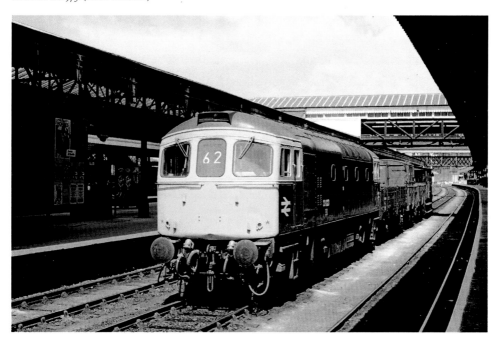

June 1974 started with a bang as tragically twenty-eight people lost their lives in a massive explosion at Flixborough on the first of the month. A visit to Exeter captured No. 33023 on a local trip working during the same month. (Arthur Wilson)

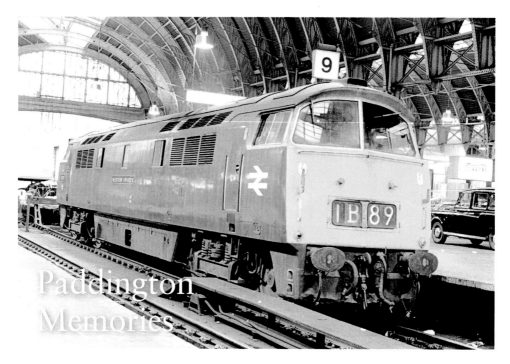

Paddington
Memories

Another shot of D1009 *Western Invader* having just been released from its train at the buffer stops on 15 March 1975. This month saw the release of the hilarious 'Return of the Pink Panther', starring Peter Sellers, to cinemas around the country. (Strathwood Library Collection)

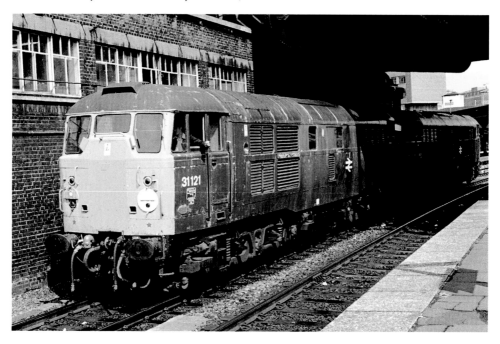

At the country end of the station we find an unusual pairing of two Class 31s, Nos 31121 and 31123, on 24 July 1979. The leading engine had arrived in the region back in December 1968. To reduce draughts for the crew, the original connecting doors have been plated over. (Stuart Broughton)

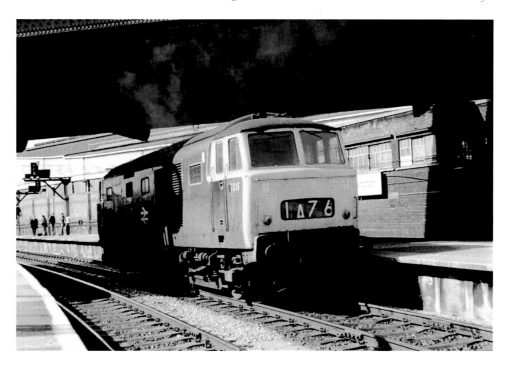

A small group of spotters at the platform end await the departure of Hymek D7018 light engine towards Royal Oak on 7 April 1973. The girls' heart-throb Donny Osmond was at the top of the charts with 'The Twelfth of Never'. More of interest to some of us musically was that Thin Lizzy and Slade were on tour. (Steve Ireland)

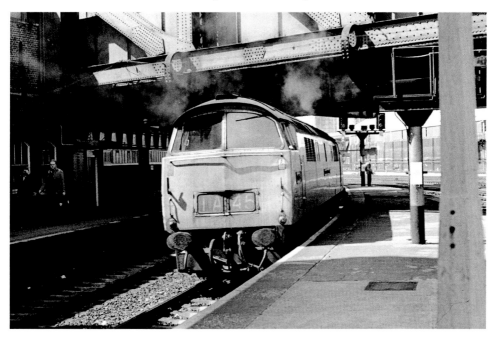

Another visit a year later found D1026 *Western Centurion* backing down onto the stock for a later departure. Terry Jacks hogged the charts with 'Seasons in the Sun', until Abba won the Eurovision Song Contest and Terry Jacks met his Waterloo after four weeks at number one during that month. (Steve Ireland)

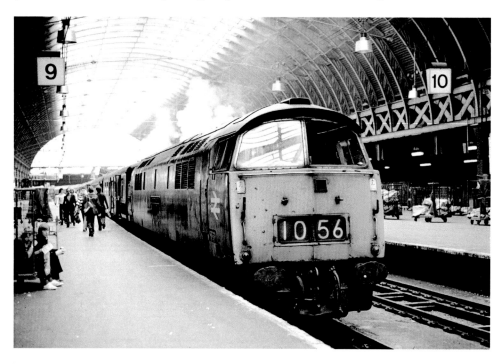

The air is thick with Western fumes in 1976 as D1056 *Western Sultan* awaits the departure of the stock it has brought in. Although this was to be the locomotive's last year in service, it would linger on until the end of May 1979 before finally being scrapped. (Richard Parkinson)

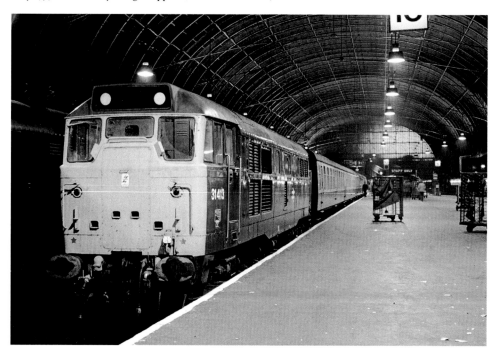

Saturday 25 August 1979 and our cameraman has set up his tripod at Paddington to record No. 31413 standing at Platform 10. When the first station opened in 1838, the line only went as far as Taplow. (Colin Whitbread)

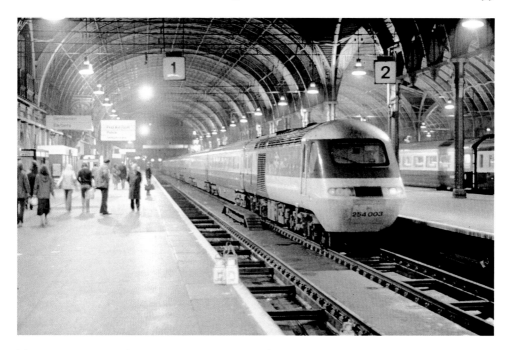

More work with a tripod and the invasion of the High Speed Train has begun, although a collection of oil lamps remain to protect the rear of loco-hauled trains in this view on 22 October 1977. By the start of that summer's timetable, the full complement of twenty seven Class 253 units were in traffic, so the arrival of a Class 254 eight-car set from the Eastern Region was unusual. (Aldo Delicata)

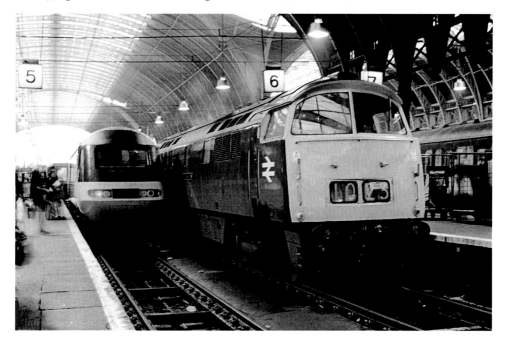

One of the new Class 253 HST sets has just pulled up alongside D1023 *Western Fusilier* standing at platform 6 on 23 October 1976. By this date just eighteen Westerns were still in traffic, with only seven destined to see service into 1977, so every opportunity to photograph one had to be taken. (Strathwood Library Collection)

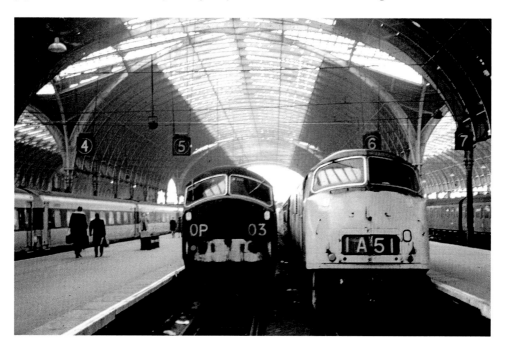

The HST concept can trace its routes to Blue Pullman units dating from 1960. One of these units awaits departure from platform 4, while an unidentified Class 22 and a Class 43 Warship idle at the buffer stops in 1970. A sobering thought to remind ourselves of was the average house price for this year was £4,874. (Peter Halsall)

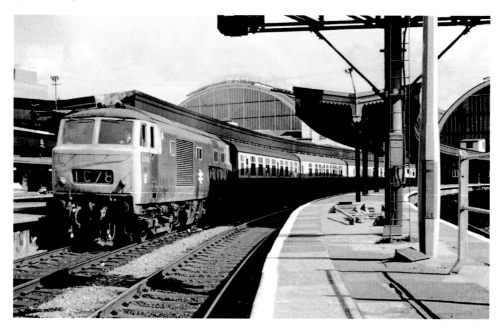

Delivered new from Beyer Peacock's Gorton factory and entering service on 26 March 1962 was D7026, seen here eleven years later on 7 April 1973. The average working life for a Hymek was under fourteen years. This one was taken out of traffic on 6 October 1974, although its remains were seen as late as February 1977 in Cohen's scrap yard at Kettering. (Steve Ireland)

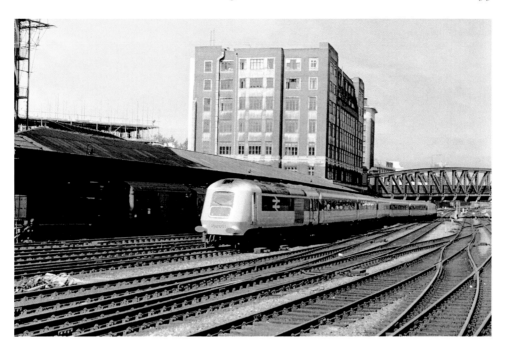

Mainline running trials had begun during the autumn of 1972 of the HST prototype Class 252 set. In the distinctive reversed blue and grey livery we see the set arriving at Paddington on 16 June 1975. When this set was withdrawn from service, one each of the trailer firsts and trailer seconds were converted for the Royal Train. (Ian James)

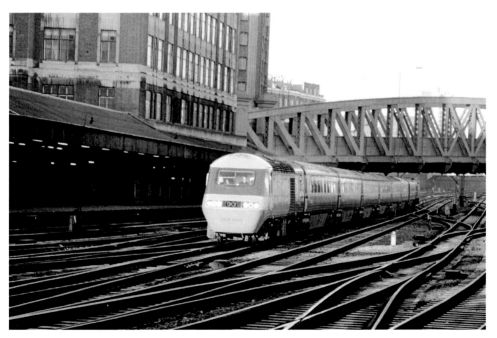

From a similar vantage point at the platform ends on 5 March 1978, one of the Class 254 power cars leads an HST set into the London terminus. Touring the UK at this time were Squeeze as a support group yet to release their biggest hits 'Cool For Cats' and 'Up the Junction' a year later. (Ian James)

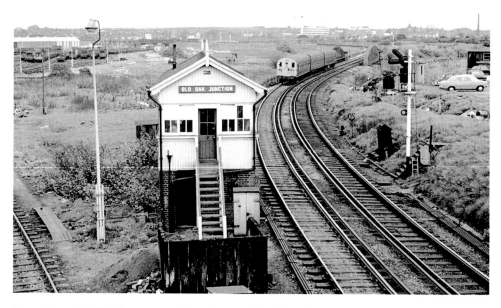

The occupants around the turntable, from a vantage point close to the canal bridge, show a tempting mix of Westerns, Hymeks and Class 47s for our notebooks if we can get round, which I am sure we will. When this shot was taken on 21 May 1971 we would expect to find a couple of Warships and Class 22s on shed somewhere too. (Derek Whitnell)

Most visits to Old Oak Common would have been made via North London electrics and Willesden Junction seen in the background as this Broad Street-bound set rattles across the Regent's Canal bridge on 2 May 1975. Always an easier depot to bunk around back then, with entry either via the front entrance or more discreetly, if needed, via the gap in the wall along the canal towpath. (Peter Halsall)

With a background of the enginemen's overnight lodgings, we find three Hymeks and a Class 47 getting a quick screen wash on 16 July 1972. By this date a number of withdrawn hydraulics would be found behind the carriage sheds used to maintain the Blue Pullmans, where we see one of the six-car ex-Midland sets on this same visit. (Both shots by Frank Hornby)

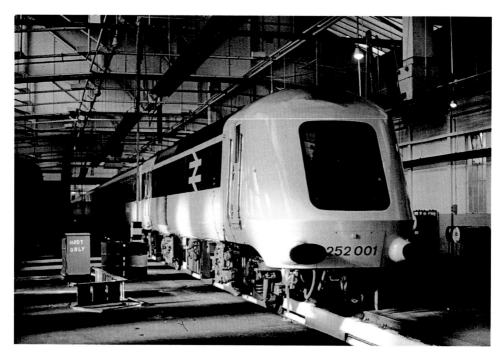

Inside that same shed two years later on 16 December 1974 we find No. 252001 between test runs showing us a little of what was to come the following summer as HSTs started to arrive en masse. (Strathwood Library Collection)

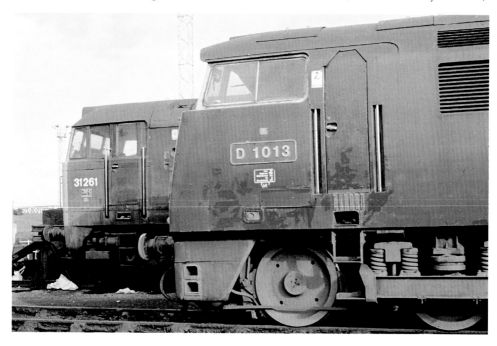

Less than a week from being withdrawn D1013 *Western Ranger* shows off the distinctive red-backed number plates which matched the nameplates at the end, seen keeping company with No. 31261 on Monday 21 February 1977. Two more weeks and the locomotive would go to Newton Abbot for storage before preservation at Paignton initially on 6 June 1977. (Colin Whitbread)

A move across to the refuelling shed next finds D1025 *Western Guardsman* showing a Z headcode after working a special to Newquay the previous day. Also inside the shed on 2 May 1975 was No. 47076 which had been named as *City of Truro* in a ceremony at Truro on 8 June 1965 when carrying the original number of D1660. Adoption of the TOPS number took place in February 1974. (Both photographs by Peter Halsall)

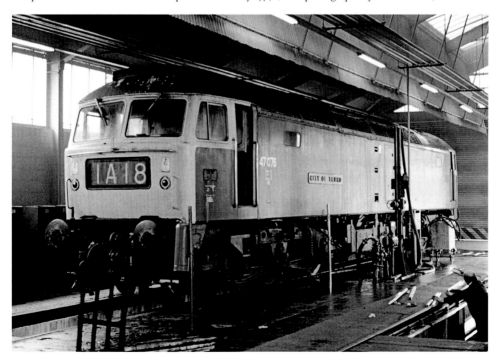

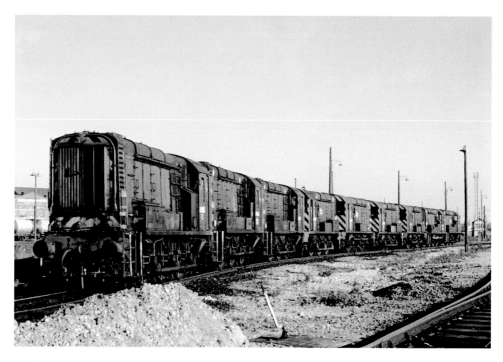

Leading off a rake of nine Class 08 shunters in this 1971 view was D3965, which was sent new to 81A in May 1960, before a two-year stay at Tyseley and a return to Old Oak Common, where it would stay until November 1983. (Roger Griffiths)

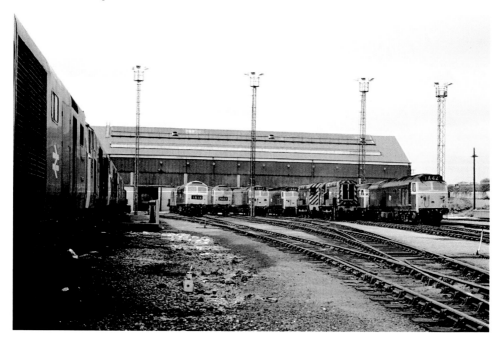

Looking back this time, we see a long line of six withdrawn Hymeks on 2 May 1975 towards the heavy maintenance shed now dominated by Classes 50 and 47. Inflation was running wild and the average house price had now almost tripled from the start of the decade to £11,396. (Peter Halsall)

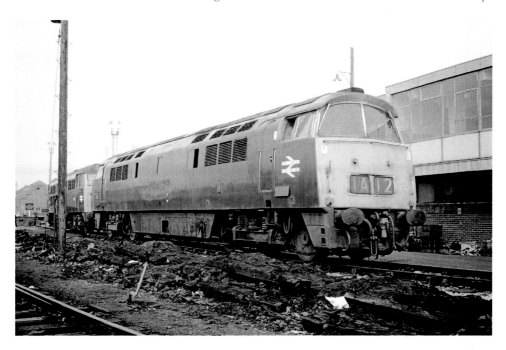

Back to the hydraulic era and 14 March 1971 finds D1059 *Western Empire* stabled among the debris of a re-sleepering exercise in front of the offices. This Western was still on the books at Bath Road at this time, before the class became centred on Laira for their last few years. (Frank Hornby)

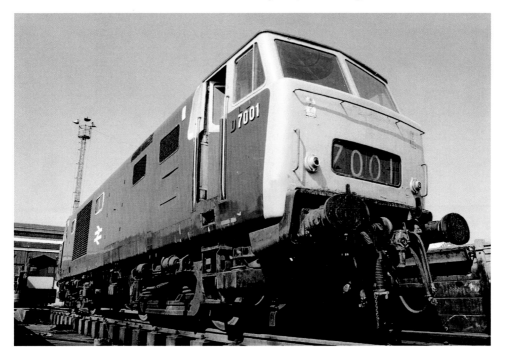

An interesting low-wide-angle view of the second built Hymek D7001 in April 1974. This was the year that Ronnie Barker's wonderful characterisation of Norman Stanley Fletcher first appeared on our television screens in 'Porridge'. (Sylvester Booth/Strathwood Library Collection)

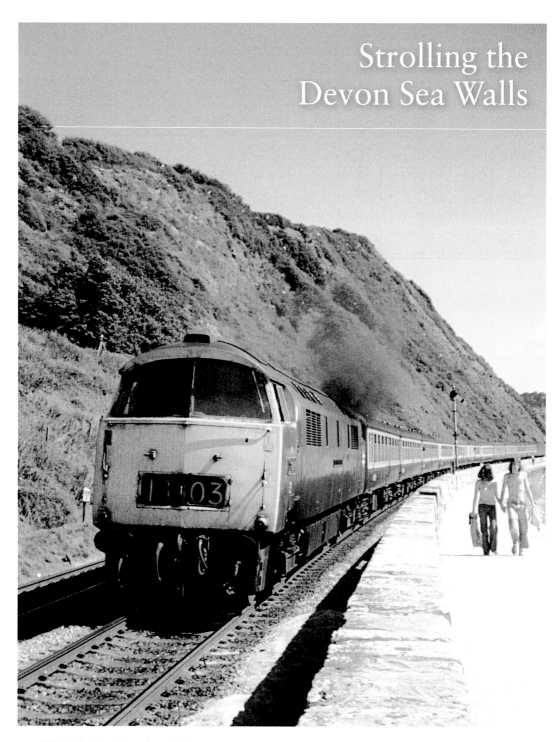

Strolling the Devon Sea Walls

With a familiar show of smoke, D1072 *Western Glory* rumbles past this couple in July 1974, when a few weeks later the engine would be set aside at Laira minus its engines for at least a month, before being refitted with engines and restored to use until early November 1976. Among other events of July that year was the heavyweight dispute between Greek and Turkish forces resulting in the partition of Cyprus. (Richard Icke)

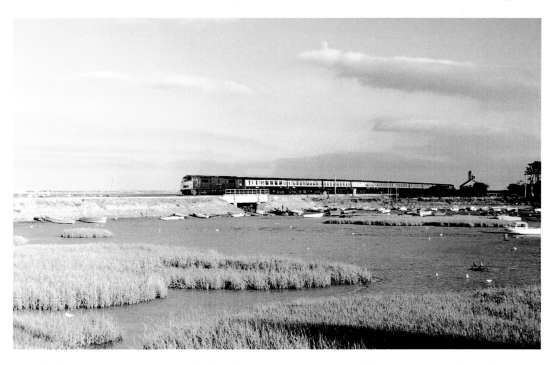

Passing the picturesque harbour at Cockwood towards the eastern end of this famous stretch of line is D1043 *Western Duke*, also in July of 1974. This Western had been repainted into a version of blue with half-yellow ends from the original maroon livery as early as 22 December 1966. (Ian Harrison)

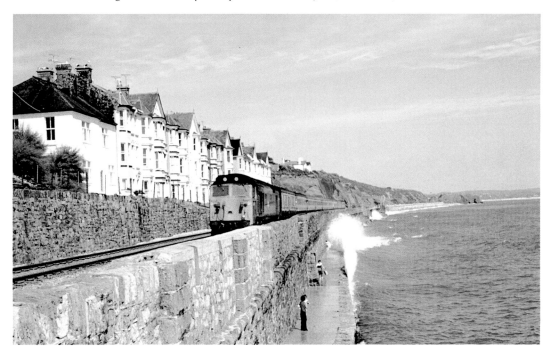

The potential dangers to cameramen and their cameras from the sea spray, even on a sunny day, can be seen in this study of Class 50 No. 50018, yet to be named *Resolution* when taken on 23 August 1977. (Sid Steadman)

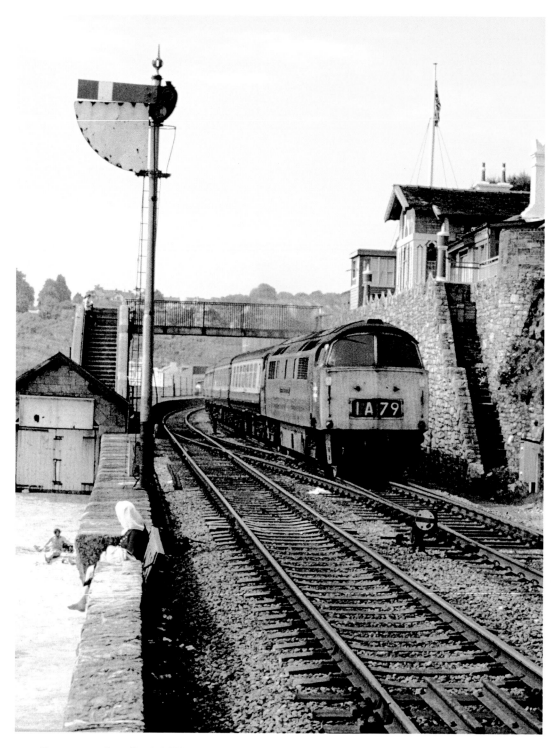

Getting away from Dawlish Warren on 11 August 1973 was D1000 *Western Enterprise*, attracting only the attention of our anonymous lensman. This was the year that 'The Exorcist' would seem to disturb everyone who saw it at the cinema. The film went on to win two Oscars. (Strathwood Library Collection)

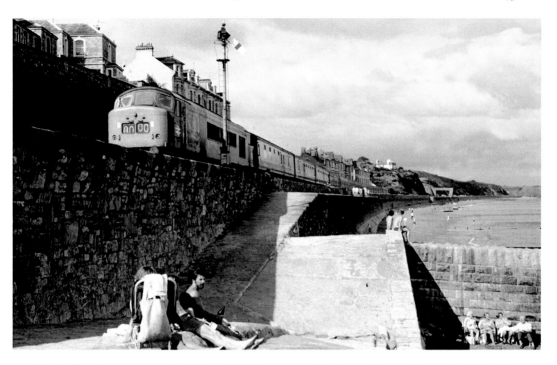

Barely disturbing anyone at Dawlish was Peak No. 45032 on Tuesday 20 July 1976. Across the Atlantic in Montreal, the world was celebrating the Olympics without twenty-five African nations who had pulled out in protest over New Zealand's sporting links with South Africa. (Colin Whitbread)

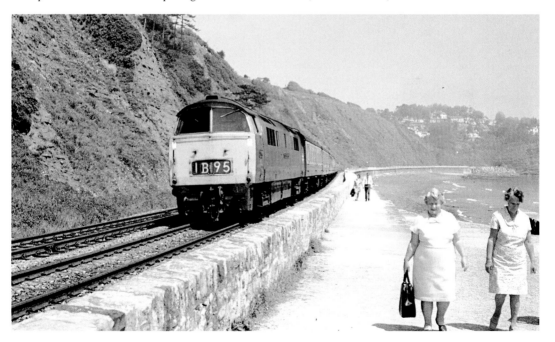

About to sweep past these two ladies is D1066 *Western Prefect*, near Teignmouth on 16 June 1973. The Western would blot its copybook in a collision at Newton Abbot on 10 November 1974, resulting in withdrawal the next day. (Strathwood Library Collection)

Early August 1974 near Dawlish Warren and a few people have gathered on the footbridge to watch the passing of D1053 *Western Patriarch* light engine. (Ian Harrsion)

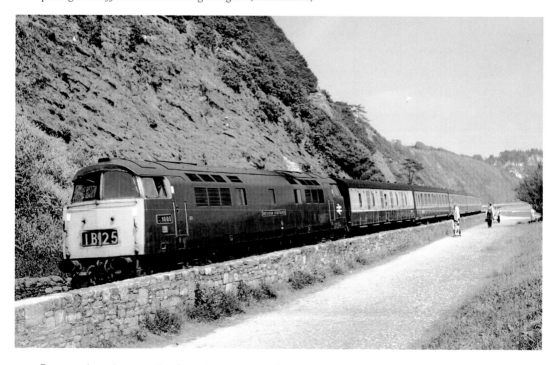

Running along the sea wall in June the same year is D1005 *Western Venturer*, showing the painting over of the D prefix on the number plates at a time when every month we were seeing so many locomotives being renumbered into TOPS. (Arthur Wilson)

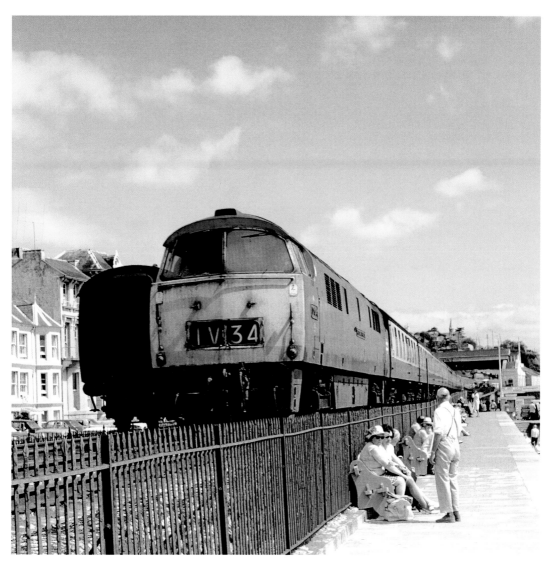

Another train pulls up at Dawlish Warren station as D1047 *Western Lord* makes its regal departure during June 1974. Away in London, on the 17th of the month the IRA were suspected of detonating bombs both in the Houses of Parliament and at the Tower of London. (Arthur Wilson)

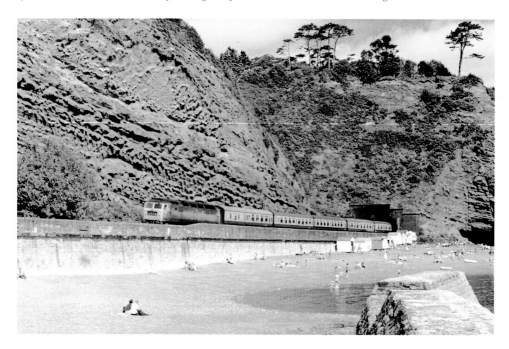

A shabby green No. 47366 bursts out of the tunnel and past Coryton Cove during August 1974. The headlines across the world were full of the resignation of President Nixon over the Watergate scandal at this time. (Ian Harrison)

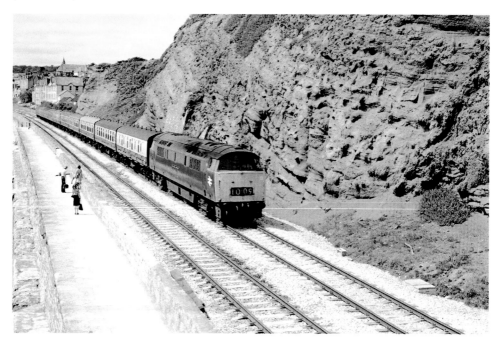

Dawlish cliffs show one of the finest continuous exposures in the country of embedded aeolian (windblown) sands and fluvial (water-laid) breccias of the Permian age. These attractive red sandstone cliffs form a pleasing backdrop to D1009 *Western Invader*, looking smart on 16 July 1976 in that last summer of regular Westerns along the sea wall. (Ian Harrison)

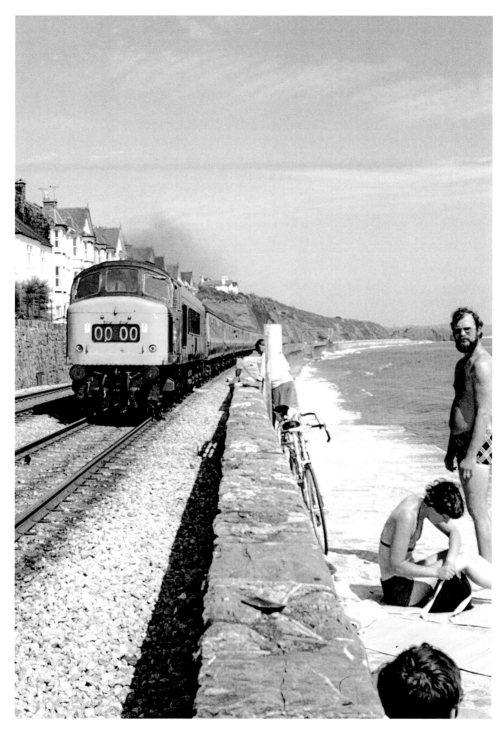

When the tide is in the footpath becomes busier, as can be seen on the approach of Peak No. 45008 at Dawlish on 23 August 1977. Possibly a popular winner for the lady looking in her handbag, but not with the gentleman glaring at our cameraman, was that year's Grammy Song of the Year by Barry Manilow with the appropriate title 'I Write the Songs'. (Sid Steadman)

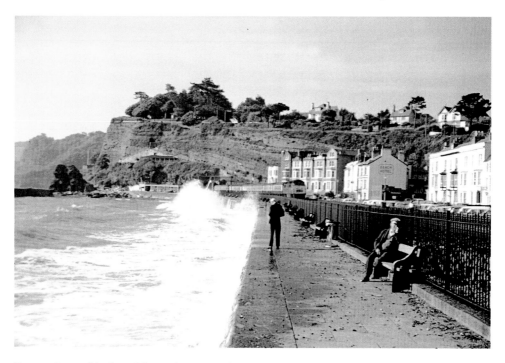

Some evidence of the fury of the sea this time, with waves lashing the railway, throwing up stones and washing away ballast along this stretch of the mainline. Approaching in this scene on 8 September 1971 is D1023 *Western Fusilier*. (Ian Harrison)

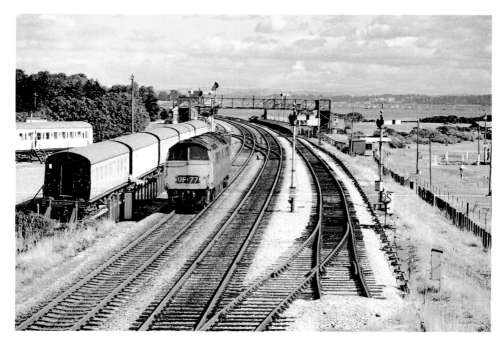

Running light engine past the camping coaches at Dawlish Warren is D1025 *Western Guardsman* on 14 July 1975. Such accommodation for railway staff was first provided here in 1935 by a benevolent Great Western Railway. (Ian Harrison)

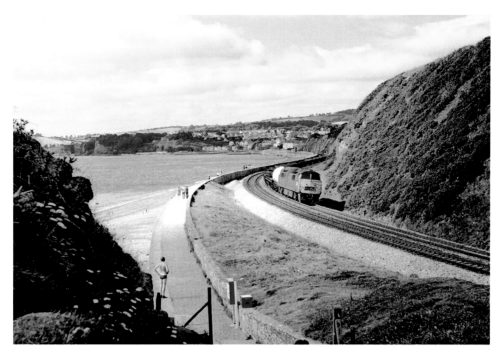

With a long rake of empty car flats behind it at Langstone Rock, catching the attention of at least one holidaymaker is D1033 *Western Trooper* on 29 July 1974. (Ian Harrison)

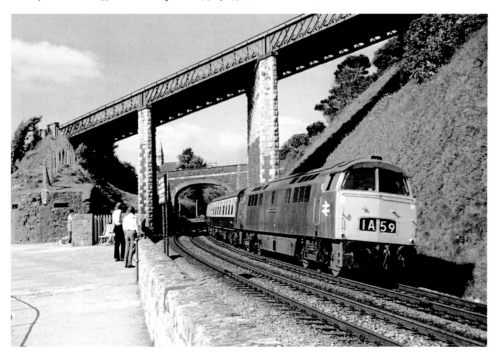

Emerging from Eastcliffe Cutting on to the sea wall at Teignmouth with a Plymouth to Paddington service is D1064 *Western Regent* on 3 August 1972. Among the important albums that year was 'Harvest' by Neil Young. Note the Second World War pillbox – happily never needed. (Richard Icke)

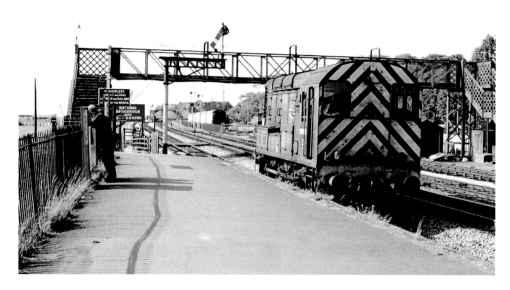

Hopefully making swift progress along this busy section is Class 08 shunter No. 08955, given the clear ahead by the lower quadrant semaphore from the platform at Dawlish Warren station. (Ian Harrison)

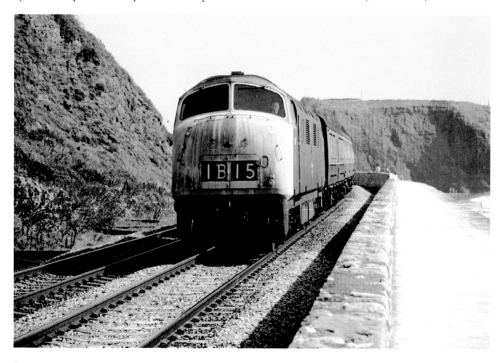

Showing some interesting weathering marks on that classic Warship nose design is D818 *Glory* near Dawlish in August 1972. Transferred to Laira from Newton Abbot in January, this locomotive was withdrawn as of 1 November that year. (Roger Kaye)

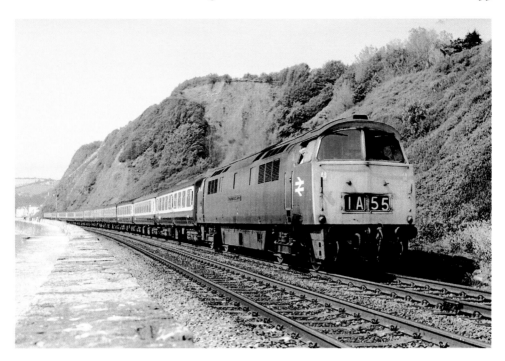

With the crew enjoying the fresh sea air, D1015 *Western Champion* leaves an exhaust trail in its wake accelerating away from the Dawlish stop in May 1974. (Arthur Wilson)

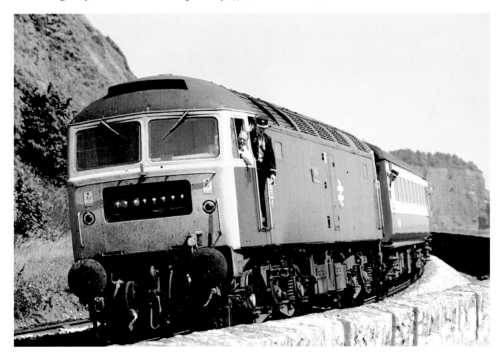

Also enjoying the fresh air and riding shotgun is the pilot man on board Class 47 No. 47513, recently named *Severn*, as the driver creeps his charge slowly into Teignmouth station. The line is blocked two hundred yards ahead by the preceding train, which had failed on 27 July 1979. (Greg Wyett)

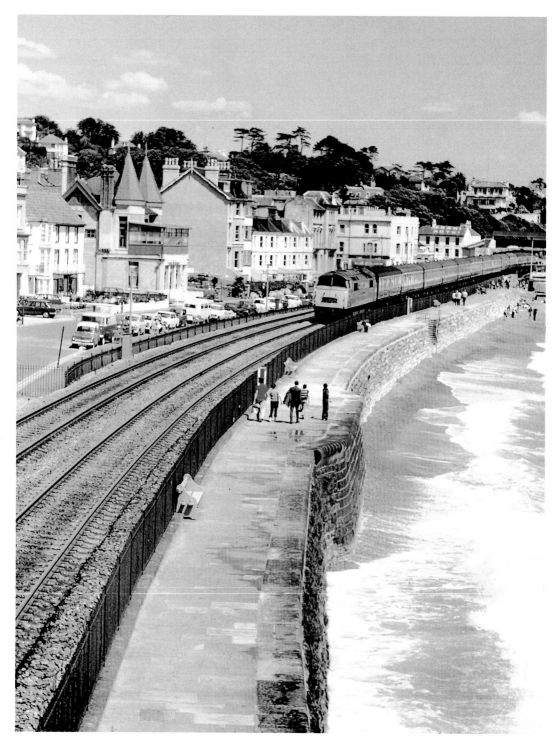

Closing this chapter with a viewpoint from the footbridge looking back towards Dawlish station on 1 June 1975 as the tide ebbs and D1054 *Western Governor* gets another heavy load of holidaymakers underway again. (Ian Harrison)

Specials

Having made an extended stop on their return from Exeter St Davids to allow a short visit to Swindon Works, darkness has fallen on Swindon station as passengers join Class 40s Nos 40084 and 40081 for the return to Paddington on Sunday 9 October 1977. (Colin Whitbread)

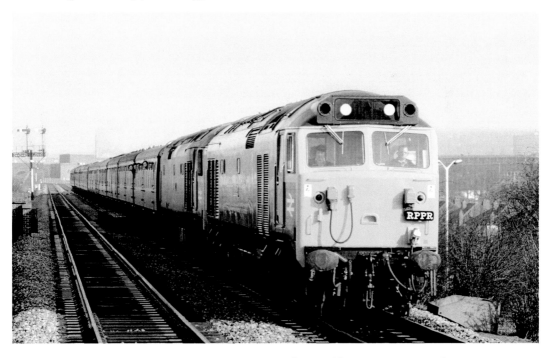

Another English Electric pairing on 18 March 1978 saw Class 50s Nos 50048 *Dauntless* and 50010 *Monarch* recently named on a tour from Paddington to Derby and return, seen here at South Greenford. (Aldo Delicata)

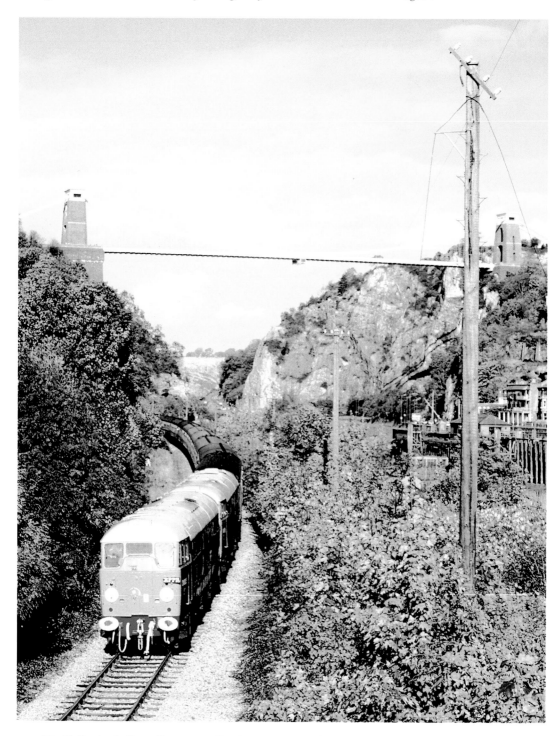

The Toffee Apple Farewell tour on 22 October 1977 brought Class 31s Nos 31005 and 31019 to the unlikely route along the banks of the River Avon and underneath Brunel's famous Clifton Suspension Bridge. In the end both engines would remain in service until early 1980, before going to Doncaster Works for disposal. (Roger Griffiths)

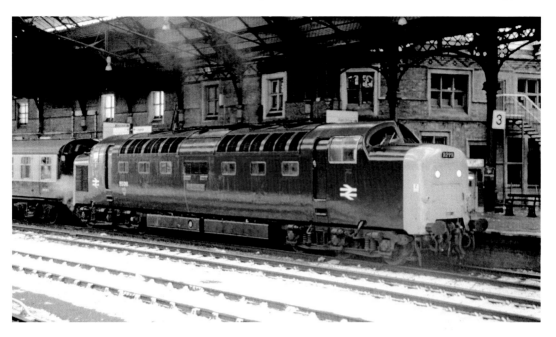

Another Eastern Region interloper in the shape of No. 55018 *Ballymoss* on the eventful first running of the *Deltic Ranger* tour on 19 February 1978. Booked to run from Paddington to Paignton and a run on the preserved line with the two Westerns D1013 and D1062, the tour was halted at Bristol due to major blizzards in the West Country. Officialdom turned the tour back on the direct route to the capital, although the organisers asked for a routing via Birmingham as a consolation. Instead, the tour arrived back at Paddington a staggering seven hours early. I know Deltics are fast but! (Ian James)

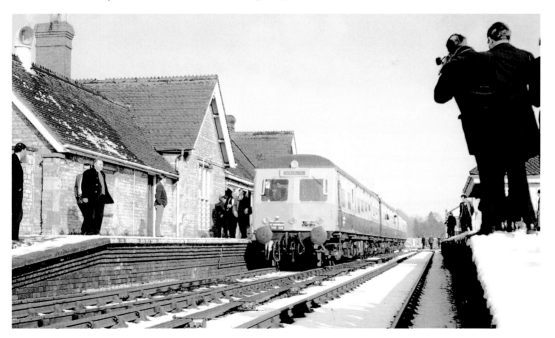

More snowfall for the RCTS-organised Thames & Cherwell rail tour on 11 April 1970 on a photographic stop at Witney on the Yarnton to Fairford branch, closed in 1962. (Strathwood Library Collection)

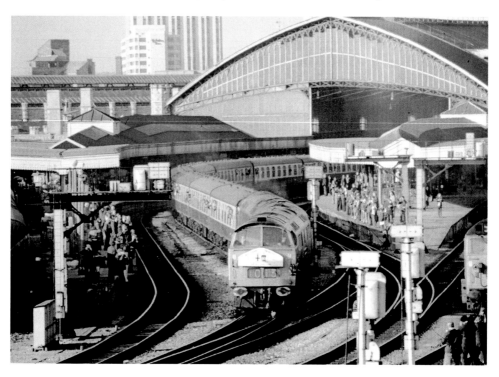

A good turnout of the faithful both on board and along the route, here seen at Bristol Temple Meads on 26 February 1977 for the British Rail Western Tribute tour with D1013 *Western Ranger* and D1023 *Western Fusilier* in charge. (Roger Griffiths)

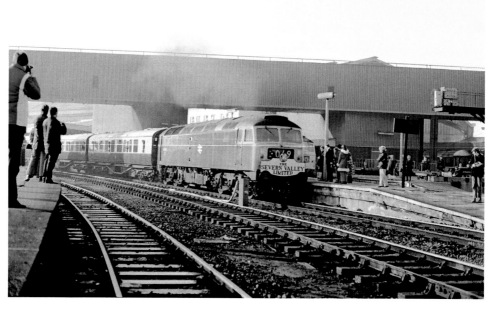

Staying at Temple Meads for another large headboard adorning Class 47 No. 47120 for a running with the preserved Great Western stock on the Severn Valley Limited in 1976. (Roger Griffiths)

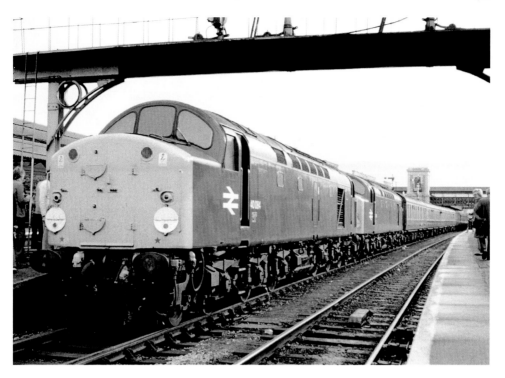

We see Class 40s Nos 40084 and 40081 again on 9 October 1977 arousing interest at Exeter St Davids involved with the changeover with Nos 25052 and 25223, which handled the run down the branch to Paignton to allow the tour participants to ride behind D1062 *Western Courier* to Kingswear and back. (Colin Whitbread)

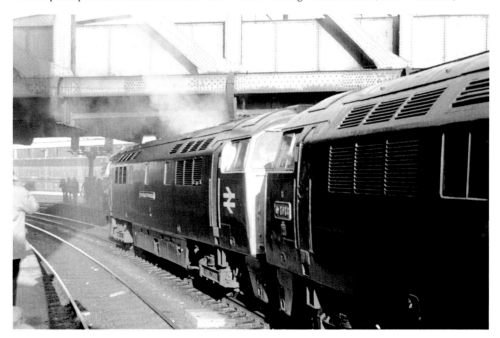

Concluding this section with that final Westerns run on 26 February 1977 with D1023 *Western Fusilier* and D1013 *Western Ranger* adding to the fumes at Paddington. (Ian James)

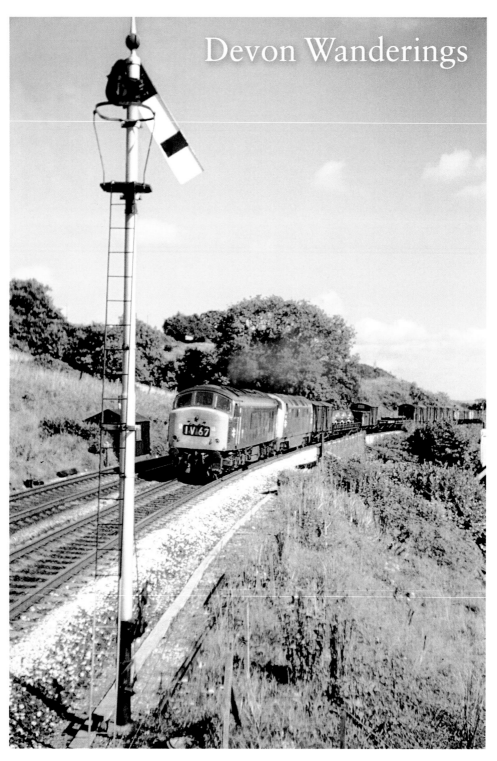

Devon Wanderings

An unknown Peak and Warship combination head a lengthy goods on Rattery, most likely after the Warship had let itself down during 1970. (Edward Dorricott)

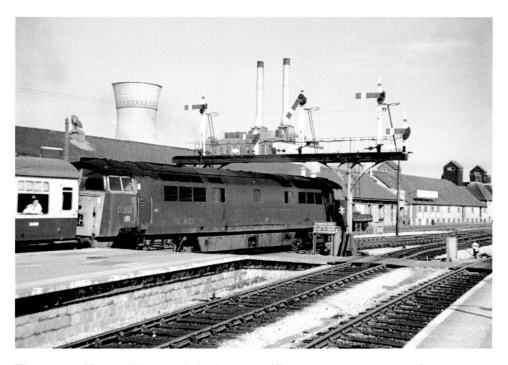

The gantry at Newton Abbot signals the departure of D1018 *Western Buccaneer* on 8 September 1971. Six months into decimalisation and many people were still confused and mourned for their old pounds, shillings and pence. (Ian Harrison)

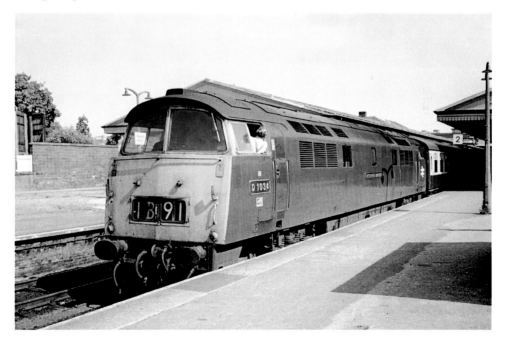

Awaiting the guard's flag at Newton Abbot is D1034 *Western Dragoon* on 8 June 1975. History shows the town's name being derived from the New Town of the Abbots (of Torre Abbey) in the thirteenth century. (Steve Ireland)

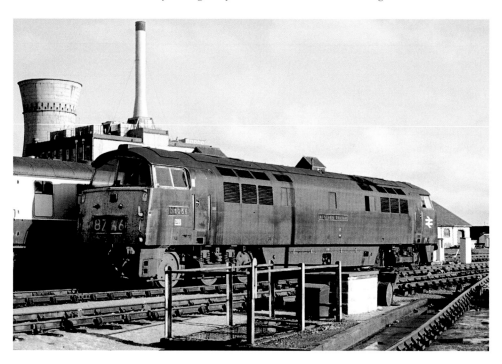

Playing spot the difference between this shot and the one on the preceding page suggests that one of the chimneys of the power station had succumbed between 1971 and June 1974 when D1056 *Western Sultan* was standing in the sun at Newton Abbot. (Steve Ireland)

Here we have the arrival of the 07.26 Paignton to Exeter St Davids DMU on Saturday 7 July 1979 into Torquay. The town would be forever famous for 'Fawlty Towers' after the first series in 1975, with the second series being made during the year of this photograph. (Colin Whitbread)

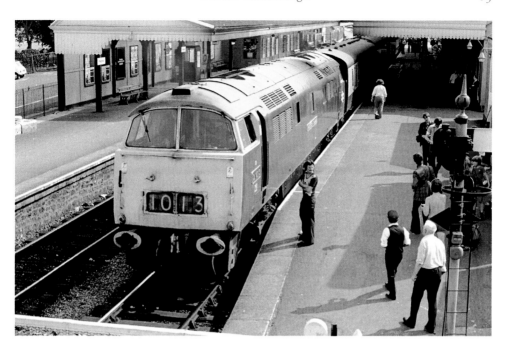

Unknown at the time on 11 July 1976, D1013 *Western Ranger* would return a year later to Paignton as a preserved locomotive before moving on to the Severn Valley Railway on 29 September 1978. (Strathwood Library Collection)

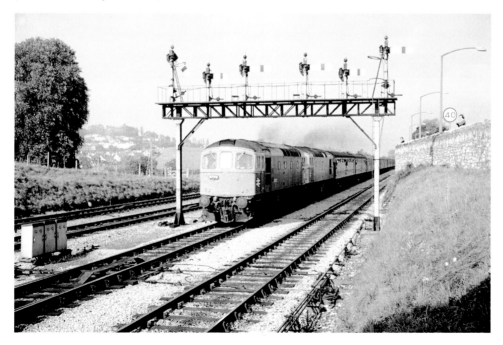

Going well at Aller Junction on 16 October 1977 are Class 33s Nos 33022 and 33017, having taken over from Class 40s Nos 40081 and 40083 at Newton Abbot on the RPPR Deltic to Devon, Cromptons to Cornwall tour which was run on the day that the Eastern Region had blacked all Deltics, so the Forties were substituted. (Strathwood Library Collection)

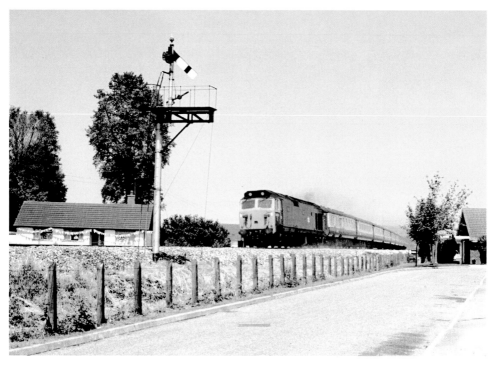

The bunting is up for the queen's Silver Jubilee in June 1977 as Class 50 No. 50013, named the following year as *Agincourt*, roars past Stoke Canon. (Strathwood Library Collection)

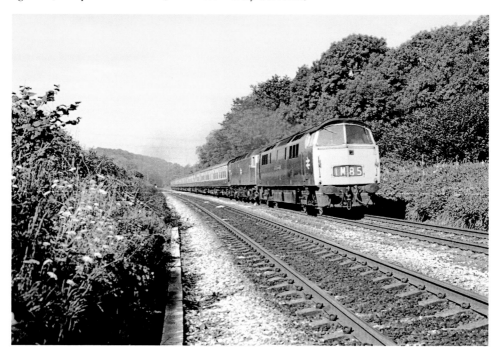

Working hard on Hemerden Bank is D1028 *Western Hussar*, assisting a lacklustre Class 47 No. 47245 on 21 August 1974 with a Liverpool-bound train. (Nick Gledhill)

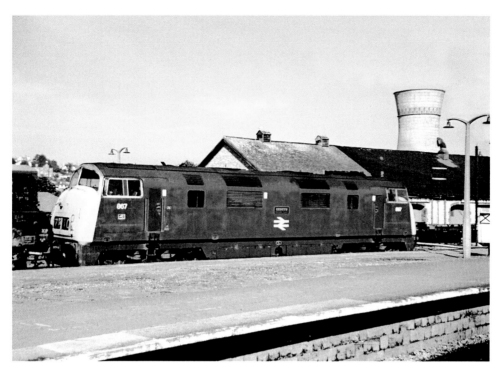

Once one of the scruffiest maroon Warships, but now repainted into blue, is Class 42 *Zenith*, five weeks away from withdrawal on 8 September 1971 at Newton Abbot. (Ian Harrison)

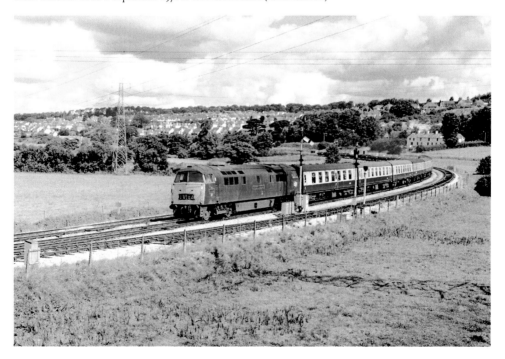

Rounding the curve at Aller Junction with a Motorail service is D1022 *Western Sentinel*, which had spent the early part of 1974 in store but was now happily back in traffic again when seen in August. (Ian Harrison)

Plymouth Hoe

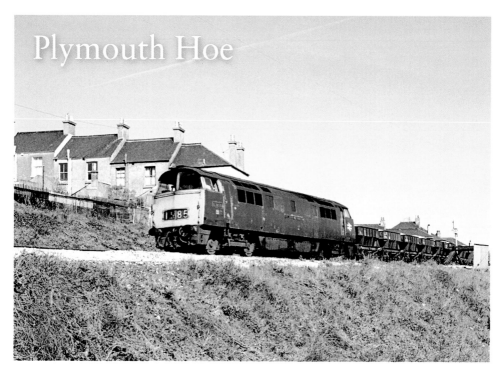

Passing on the mainline past Laira towards Plymouth on 14 April 1974 was D1026 *Western Centurian*. (Nick Gledhill)

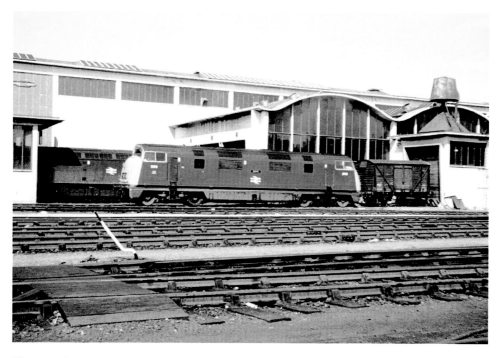

The unusually elegant sixties architecture at Plymouth Laira provides a pleasing backdrop to Class 42 *869 Zest* in 1970. (Edward Dorricott)

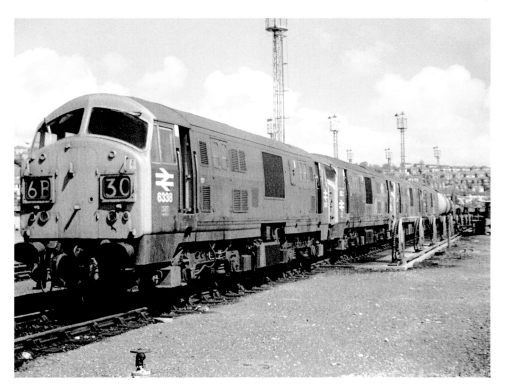

Four Class 22s led by No. 6338 await developments at Laira in 1970. (John Ferneyhaugh)

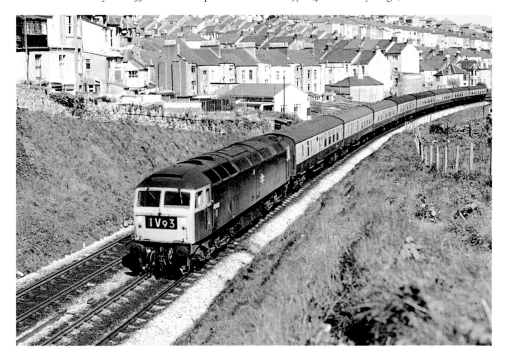

Renumbered from 1623 two months earlier, Class 47 No. 47042 brings ecs from Laira into Plymouth Tunnel on 14 April 1974. (Nick Gledhill)

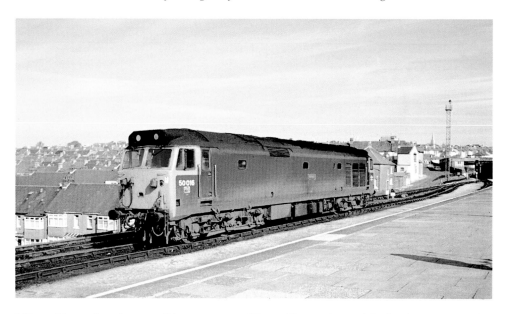

Idling at Plymouth station on 24 February 1979 was Class 50 No. 50016 named *Barham* in commemoration of HMS *Barham* which on 25 November 1941, while steaming to cover an attack on Italian convoys, was hit by three torpedoes from the German submarine *U331*, commanded by Lieutenant Hans Dietrich von Tiesenhausen. The torpedoes were fired from a range of only 750 yards, providing no time for evasive action, and struck so closely together as to throw up a single massive water column. As she rolled over to port, her magazines exploded and the ship quickly sank, with the loss of 841 men or over two thirds of her crew. Do take the time to visit www.hmsbarham.com for more information and to view the film of her sinking which was withheld until the end of the war and you will understand why we dedicate this book to the men of HMS *Barham*. (Derek Whitnell)

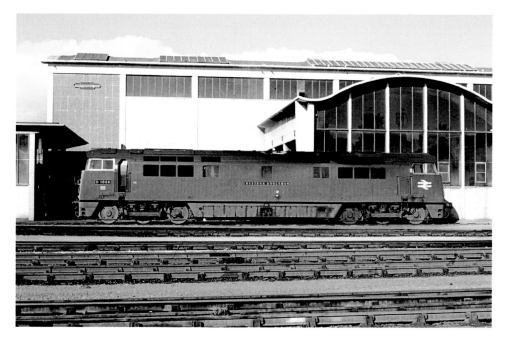

Found on shed at Laira October 1973 was D1058 *Western Nobleman*. (Steve Ireland)

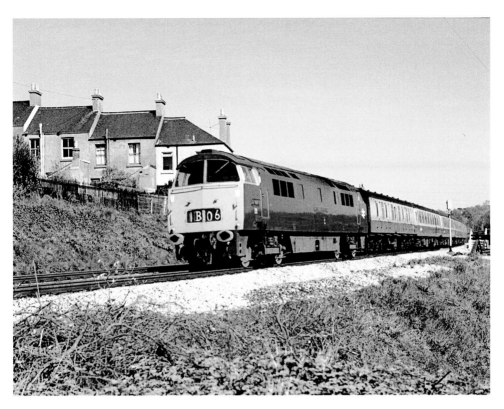

Looking cleaner than the coaches it is pulling is D1023 *Western Fusilier*, passing Laira on 14 April 1974. (Nick Gledhill)

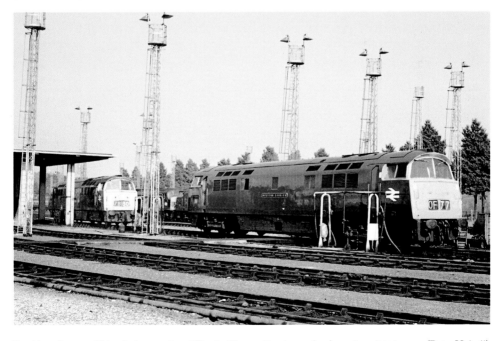

Looking cleaner still is a Laira-repainted D1062 *Western Courier* on the depot in a visit in 1973. (Peter Halsall)

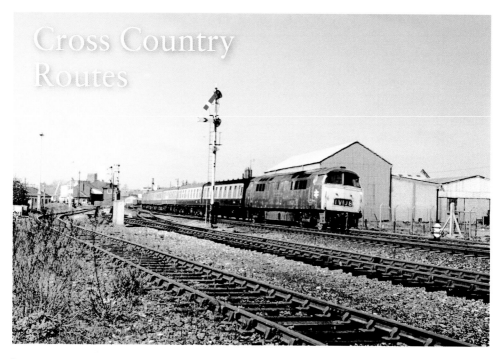

In contrast to the previous shot is D1036 *Western Emperor*, leaving Banbury in that all too familiar tatty Western Region condition of the late sixties and seventies. This view was taken on 23 April 1975. A week later the Vietnam War would thankfully end after sixteen years of conflict. (Ian Harrison)

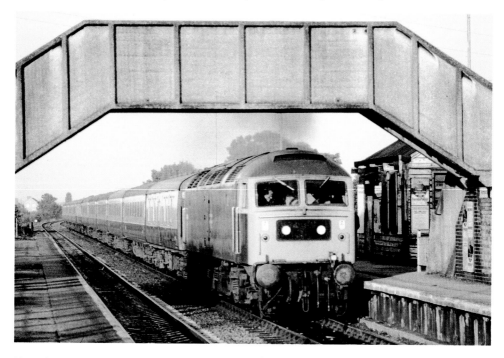

Framed by the footbridge at Northolt Park is Class 47 No. 47496 with a rake of empty coaching stock on 16 September 1978. (Aldo Delicata)

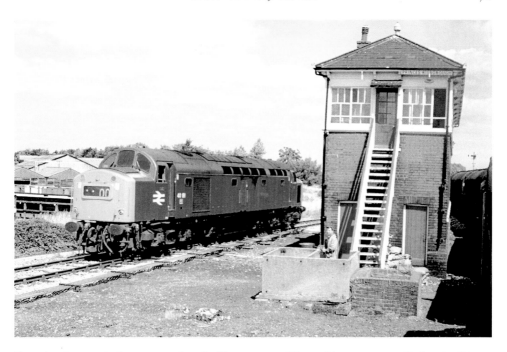

From the photographer's position on board a Class 33 we see Class 40 No. 40181, unusually found at Princes Risborough on Tuesday 25 July 1978. Far more notable on this day was the birth of the world's first test tube baby, Louise Brown, in the UK. At the time of writing over 1 million further births have taken place this way. (Colin Whitbread)

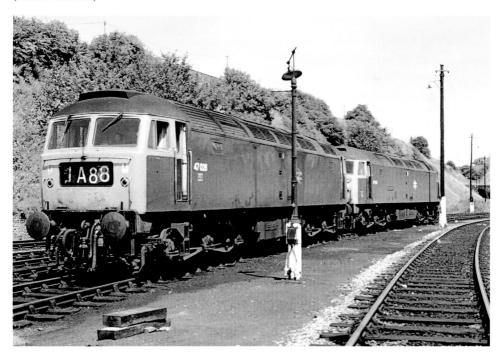

Stabled at Worcester on 21 April 1974 we find Class 47s Nos 47026 and 47085 *Mammoth*. Both engines had received their new TOPS numbers earlier in the year. (Nick Gledhill)

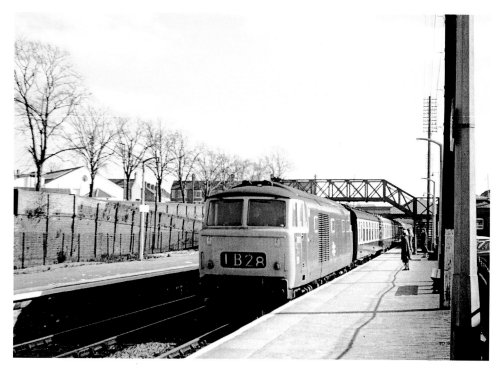

Drawing up for the stop at Evesham on 27 February 1973 is Hymek D7011. Big on television, if you will pardon the pun, were the Wombles who first appeared in 1973. (Dave Hill)

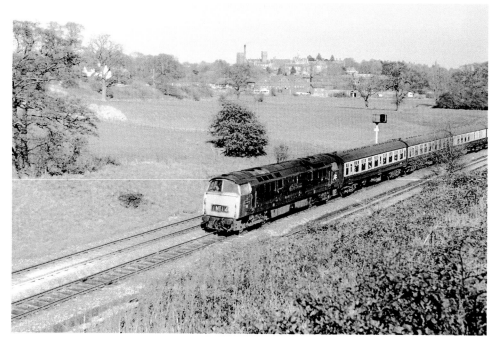

On Hatton Bank in 1975 was D1065 *Western Consort* which had been delivered new to Old Oak Common on 18 June twelve years previously and would last another year until 1 November 1976. (Ian Harrison)

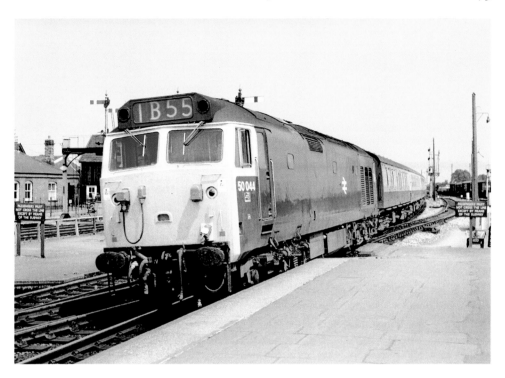

Slowing for a call at Taunton during June 1974 is Class 50 No. 50044 which had just arrived on the region, being allocated to Bristol the previous month. (Arthur Wilson)

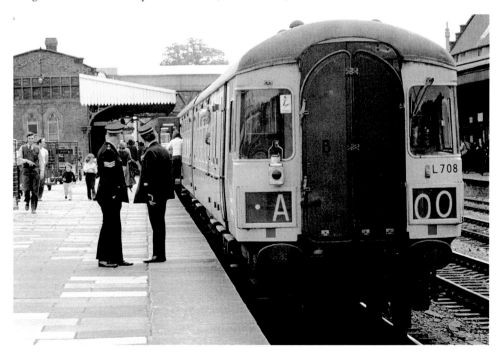

One of the stylish Swindon-built cross-country DMUs has a working at Hereford which has aroused the interests of both the guard and the police, as well as our cameraman. (Peter Halsall)

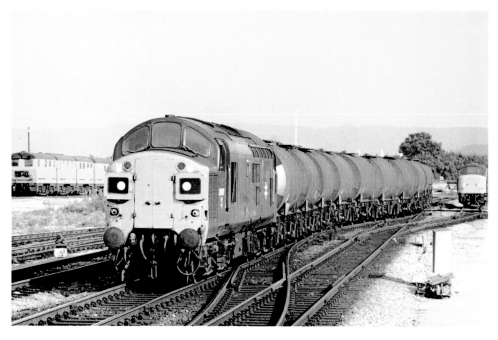

Getting a rake of tanks on the move again at Gloucester on 28 August 1978 is Class 37 No. 37077, based at far away Thornaby at the time. Holding the stars of 'Grease' off the number one spot with 'You're the One That I Want' was 'Three Times a Lady' by The Commodores. (Ian James)

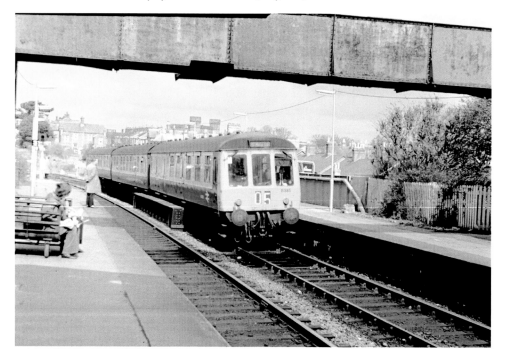

Awaiting their turn for a train at Maiden Newton were several passengers on 29 March 1975. At the end of the football season Manchester United and Aston Villa would be promoted back into Division One, while Carlisle United and Chelsea would be relegated down to Division Two. (Ian James)

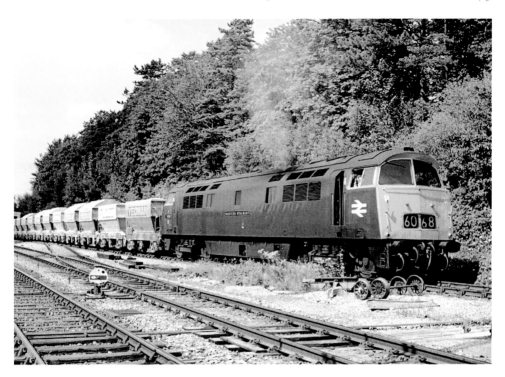

Yeoman stone trains were very much the domain of Class 52 Westerns in 1973, when we see D1006 *Western Stalwart* at Merehead on 17 August. (John Green)

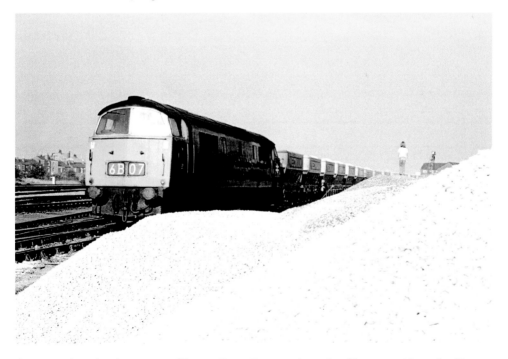

A young girl watches the progress of D1064 *Western Regent* in the yard at Gloucester with another Yeoman stone train on 29 August 1975. (Strathwood Library Collection)

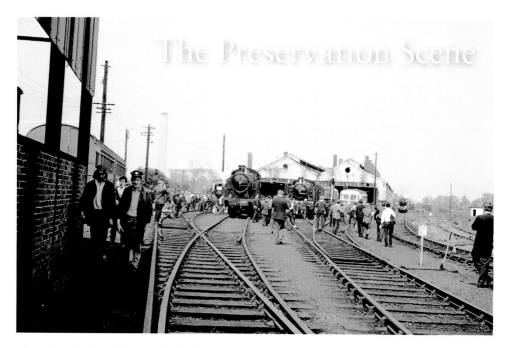

The engine shed at Didcot was closed officially by British Rail on 14 June 1965, however by the time of this scene on 15 May 1971 the Great Western Society were well at home, with a wide range of exhibits and facilities already in place. (Frank Hornby)

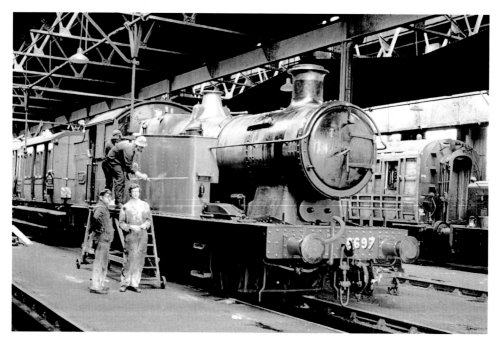

By the mid seventies the Armstrong Whitworth-built 5600 Class tank No. 6697 was photographed inside the shed at Didcot receiving a spruce up to the paintwork by society volunteers. Many preservation groups would have loved such covered facilities in which to work on what they had saved from Barry, which was often in an appalling condition after years in the open, exposed to the sea atmosphere. (Trans Pennine Publishing)

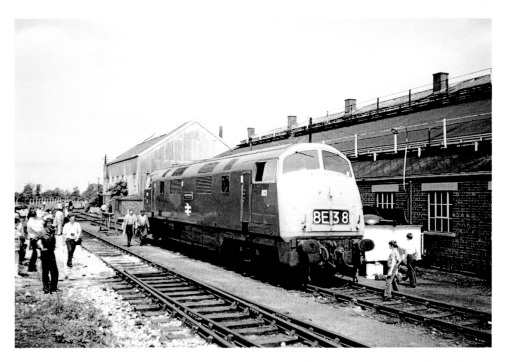

Among the steam exhibits at Didcot by the time of an open day in late May 1973 was the preserved Class 42 Warship 821 *Greyhound*, which had just arrived from storage at Swindon Works. (Bob Treacher/Alton Model Centre)

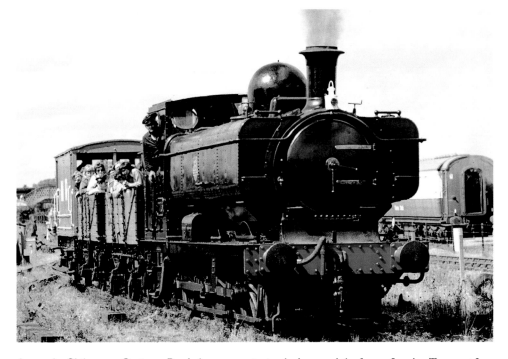

Across the Chilterns at Quainton Road, the preservationists had restored the former London Transport L99 to British Railways black livery, with many happy visitors to the centre enjoying rides in open wagons on 26 August 1974. (Aldo Delicata)

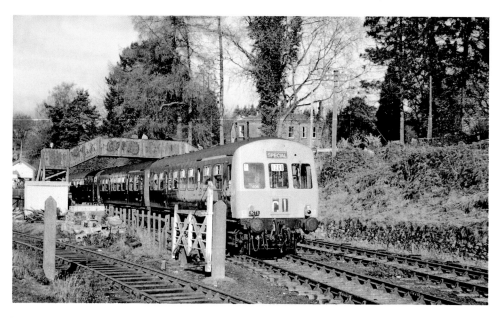

The Dean Forest Railway Society was formed in 1970 to preserve the branch line from Lydney to Parkend, although British Rail had yet to agree the closure. As a result the society made their base at the nearby Norchard Colliery site. Perseverance meant that finally the former Parkend station, which had closed in 1929, finally reopened in 2006. On 24 November 1973 the RCTS visited the former station at Parkend with their Bristol Avon No.2 Tour. (Strathwood Library Collection)

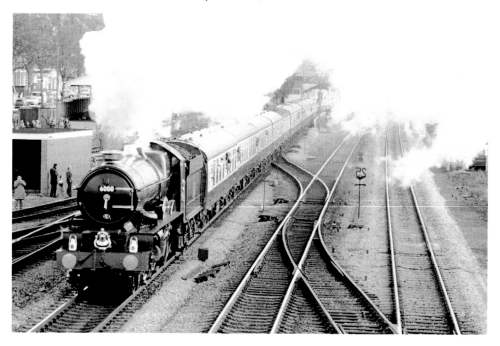

Celebrating the 125th anniversary of Paddington station on 1 March 1979, steam returned to the mainline with 6000 *King George V* running to Didcot. The King developed a suspected hot box which resulted in No. 47119 bringing the train back to Old Oak Common where the newly named No. 47500 *Great Western* was put onto the train for the run back into Paddington for the benefit of the crowds and the cameras. (Aldo Delicata)

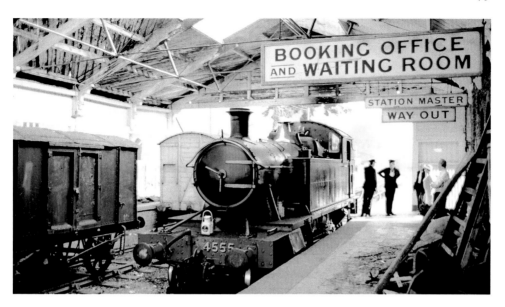

Not all preservation in the seventies went successfully, such as the Dart Valley Railway being thwarted in their attempts to save the delightful station at Ashburton. The light railway order granted in 1969 allowed the railway to run trains from Buckfastleigh from 5 April that year. However, greater powers wanted to take the A38 dual carriageway through some of the formation. Our cameraman visited on 2 July 1971 to see Prairie 4555, itself an occasional visitor to the line in British Railways days, including the last train to clear the wagons from the line upon closure, now being faced with the job again as the last train ran from Ashburton on 2 October 1971. (Aldo Delicata)

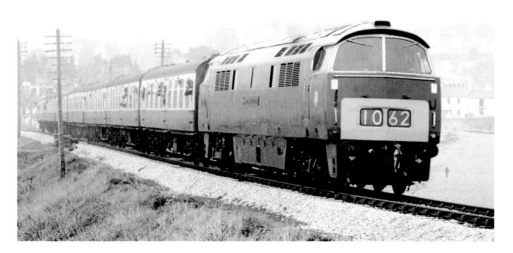

A brief spell of running on the Dart Valley Railway's other line from Paignton to Kingswear for two seasons for D1062 *Western Courier* in its early preserved guise back in maroon on 29 April 1978. The locomotive would travel first to Canton and then to a new home on the Severn Valley Railway that September. (Aldo Delicata)

Swindon Rundown Increases Pace

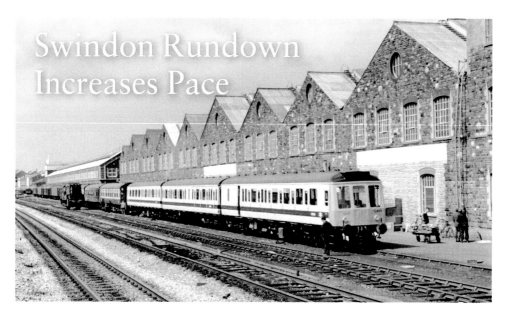

It must be said that the new refurbished livery applied to the many DMUs that passed through Swindon did look good in the sun, but keeping it clean was another matter altogether once in service. This line up was recorded on 9 June 1979 with the Class 08 being used to shunt the carriage workshops. (Ian James)

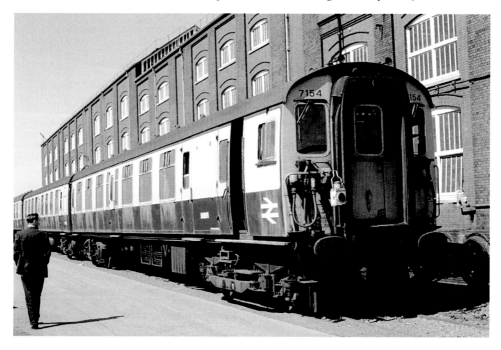

The works had employed over 14,000 men at the time of the Grouping in the 1920s. When the last steam locomotive, *Evening Star*, was turned out in 1960 the payroll had dropped to around 5,000. As a result of both recession and the speedy demise of hydraulics it had fallen to 2,200 employed in the works by 1973. A result of both refurbishment of Southern Region EMUs such as this CEP and DMU work together with the cutting up of an almost endless supply of redundant locomotives had lifted the numbers clocking on everyday back to 3,800 in 1980 before the final rot set in and closure was completed on 27 March 1986. (Colin Whitbread)

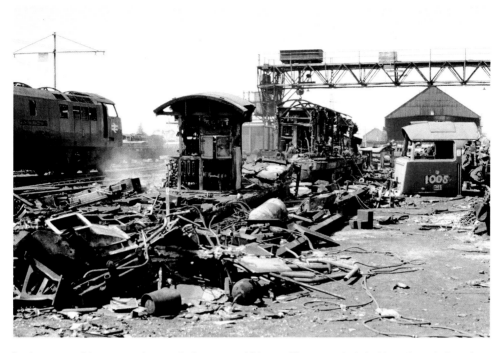

In the centre of this view is the scorched remains of Class 24 No. 24115 which had been brought here from Millerhill in Edinburgh for disposal, along with home grown Class 52s D1068 *Western Reliance* and D1005 *Western Venturer* feeling the lick of the 'gas axe' as well on 1 June 1977. (Aldo Delicata)

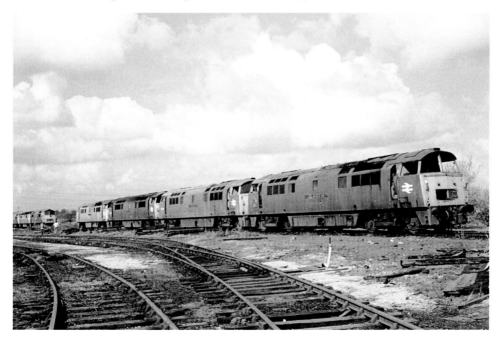

The lines of faded Westerns attracted many visitors to the works, such as on this day in April 1977. Just knocked off the number one spot at the beginning of the month was that catchy number 'Chanson D'Amour' by Manhattan Transfer, rah da da, da ... (John Green)

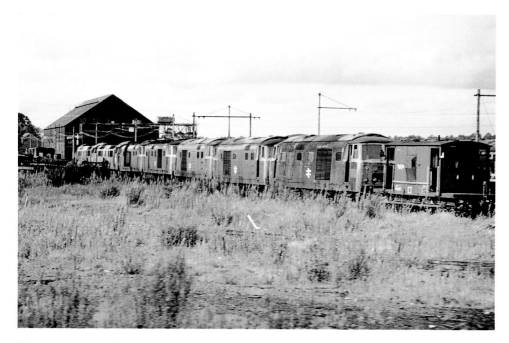

Three years before, on 31 August 1974, Hymeks outnumbered the Westerns at the back of the works in the long grass. Musically things were perhaps even worse at the time as hordes of girls up and down the country had put The Osmonds at number one with 'Love Me for a Reason'. (Roger Kaye)

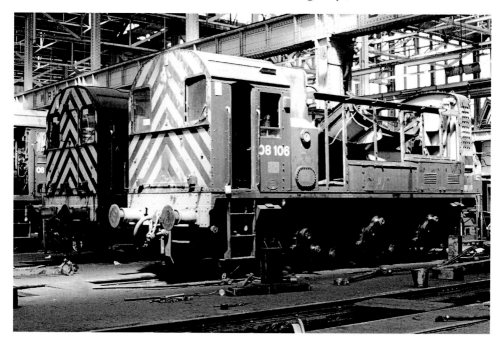

The future looks grim for Class 08 No. 08106 at perhaps being converted into a skip. However, it returned to traffic at Kingmoor no doubt having gained some vital organs donated from less fortunate shunters after this view on 19 May 1979. Like a boomerang it would be back again in May 1982, but good fortune would not save the locomotive this time and it would be scrapped in the works during January 1983. (Colin Whitbread)

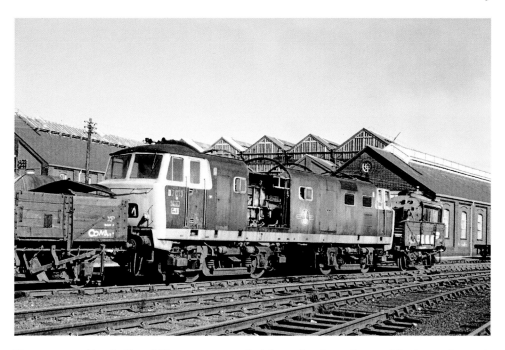

No repaint into blue for Hymek D7013 as it awaits final disposal at the works on 12 March 1972. Curiously remains of the locomotive would be sold on to a scrap dealer at Kilnhurst in Yorkshire and were seen there in March 1973. I wonder how many who saw these remains marked this Hymek as a 'cop' in their books? (Strathwood Library Collection)

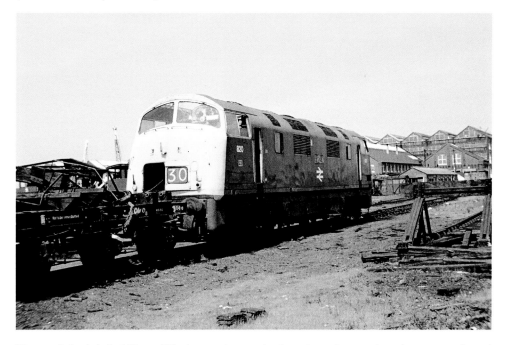

The cannibalised shell of Class 42 Warship 820 *Grenville* has been shunted out to where the cutters performed their work on 6 June 1973. Within six weeks they had completed their task and there would be very few Warships left to cut up, or would there be a late contender? (Steve Ireland)

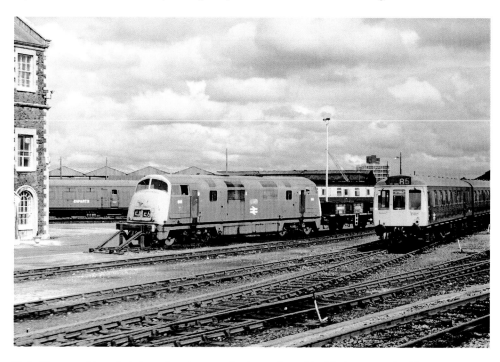

Parked into a position of relative safety, almost under the window of the Works manager's office, when seen on 31 August 1974 was Class 42 Warship 818 bereft of the *Glory* nameplates. (Ian Harrison)

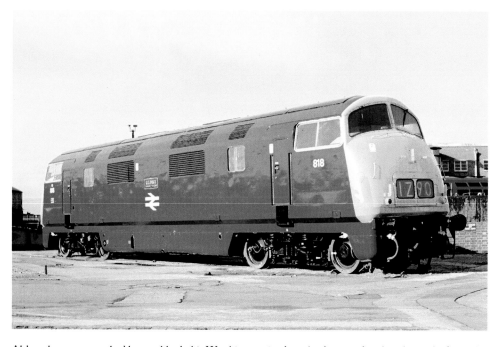

Although some spares had been robbed, this Warship remained as a 'pet', trapped within the works for twelve years, subject to repaints by apprentices from time to time, even back into green livery after this shot from 13 September 1975. Eventually this 'pet' was put down by the cutters during 1985, to the outrage of many enthusiasts. (Aldo Delicata)

London Suburbs to Reading

The driver of Hymek D7029 looks back towards his guard as his locomotive has failed almost in front of the power signal box at Old Oak Common on 30 November 1974, under a threatening sky. (Ian Harrison)

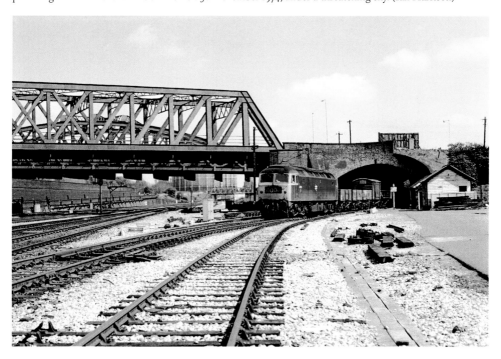

Joining the mainline at Mitre Bridge Junction in May 1976 is Class 47 No. 47184, which was based at the time at Immingham, so its appearance here would have been a rarer one for many. (Roger Griffiths)

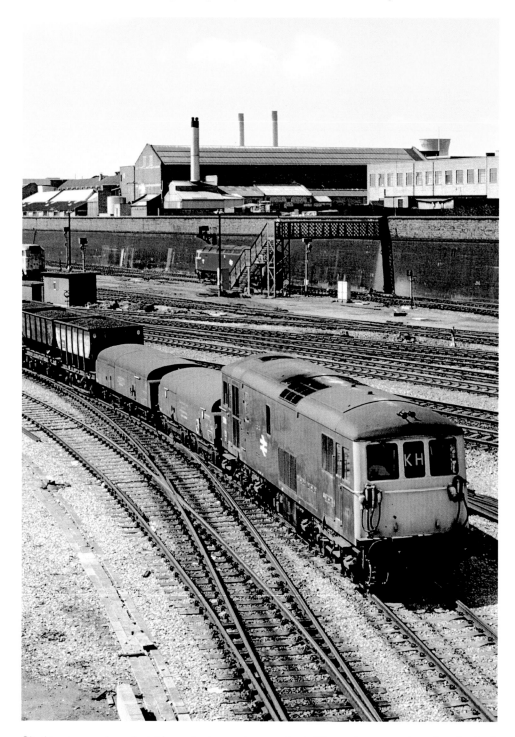

Climbing to a perch on the bridge embankment the same day in May 1976, we can enjoy a fine view back towards the carriage sidings and Old Oak Common depot as Class 73 No. 73128, with two brake tenders in tow, brings coal from West Drayton towards us, while a faded Class 31 plays with empty stock and a shiny Class 47 awaits the road off the depot. (Roger Griffiths)

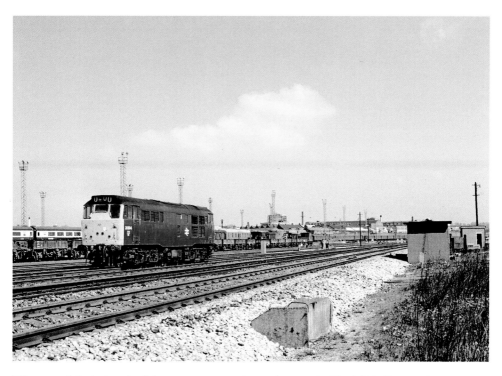

Taking a walk back along land that was many years later to become the North Pole Eurostar depot opposite Old Oak Common while a light engine Class 31 No. 31304 canters past. (Roger Griffiths)

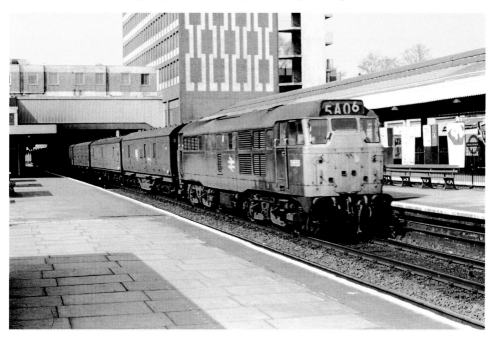

The early months of 1974 saw the mass renumbering of most of the fleet of Class 31s. One of the last to gain its TOPS number was No. 5655, seen in April 1974 bringing an empty newspaper train back towards Paddington at Ealing Broadway. (Arthur Wilson)

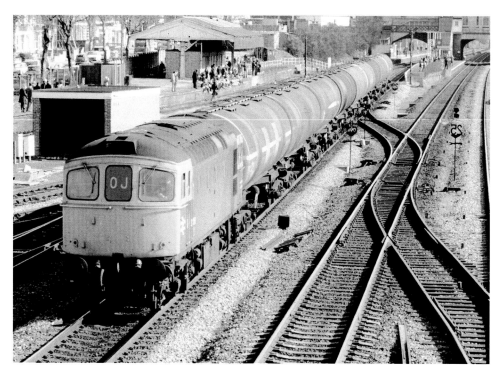

Crowds gathered as previously stated for the steam special celebrating Paddington's 125th anniversary on 1 March 1979. Whilst awaiting the special, our camerman took this fine shot of Class 33 No. 33050 heading west with a rake of tanks, with a fast-approaching HST about to overtake it on the fast line. (Aldo Delicata)

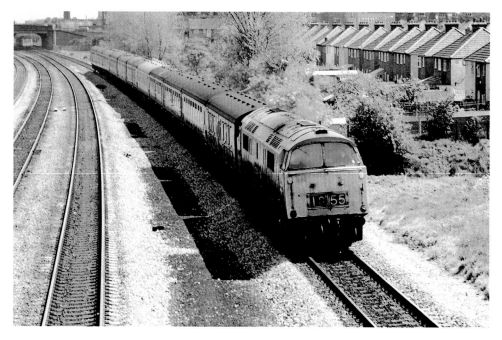

The trees are coming back into leaf on 11 May 1974 as D1065 *Western Consort* makes steady progress at Hayes. (Aldo Delicata)

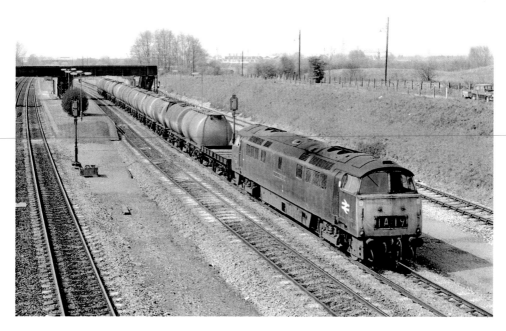

A few weeks before, in April 1974, D1059 *Western Empire* was tasked with moving another tank train when spotted at Iver station. (Strathwood Library Collection)

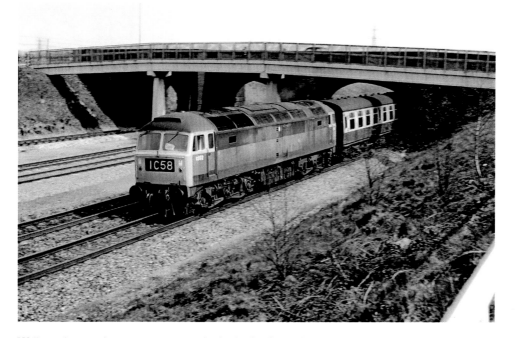

Walking closer to the station we can see the footbridge from which the previous shot was taken as we turn around to catch Class 47 No. 1592 speeding towards Reading. This locomotive was to have been renumbered as No. 47025, but in the event this was not taken up and it became No. 47544 upon release from Crewe Works in February 1975. (Strathwood Library Collection)

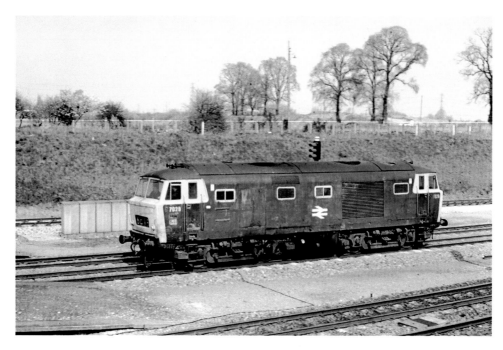

Staying at Iver, the next train is a light engine Hymek D7029 with the raised letter D painted over. After being taken out of service this Hymek would go into store at Old Oak Common for nine months before going firstly to Reading Gasworks for preservation before a further move in the seventies to Swindon Works for display and further storage. It finally left Swindon for the North Yorkshire Moors Railway on 16 April 1981. (Strathwood Library Collection)

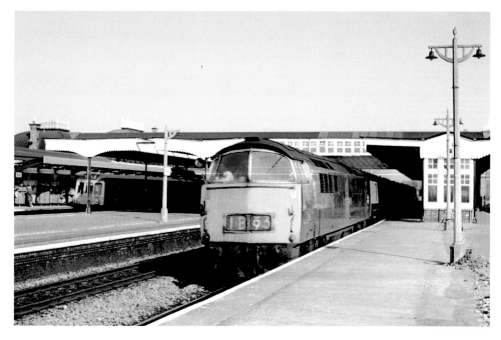

Bursting through Slough on the fast line and about to clatter across the junction for the Windsor branch is D1025 *Western Guardsman*, also in April 1974. (Arthur Wilson)

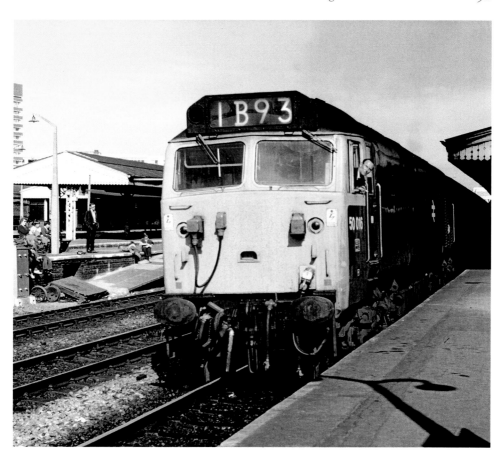

Arrival at Reading behind Class 50 No. 50016 having just arrived on the Western Region and allocated to Bristol a few days before, we catch sight of the engine on Thursday 30 May 1974. The assembled gallery in the background may well be copping this engine on their half term break. (Roger Bradley)

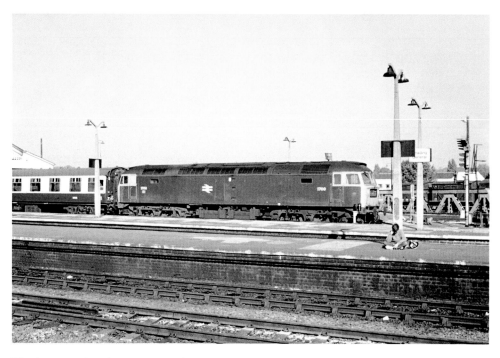

This lonesome chap does not seem to have much interest in Class 47 No. 1700 standing at Reading with a Poole train behind him on 23 September 1972. (Strathwood Library collection)

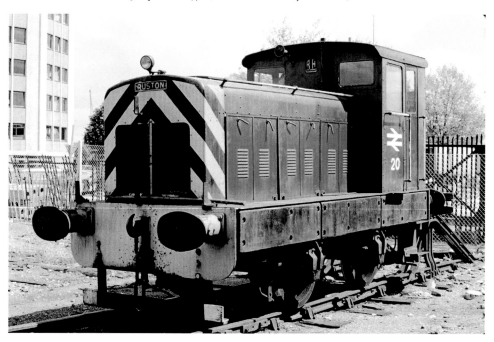

One peculiarity of Reading was the diminutive Ruston-built shunter used for the tight lines to Reading Signal Works and bearing the number 20. This must have been a gap in many a spotter's ABC at one time or another. It could be rarely seen from the passing trains and usually had to be sought out from its lair, as here in 1976. (Aldo Delicata)

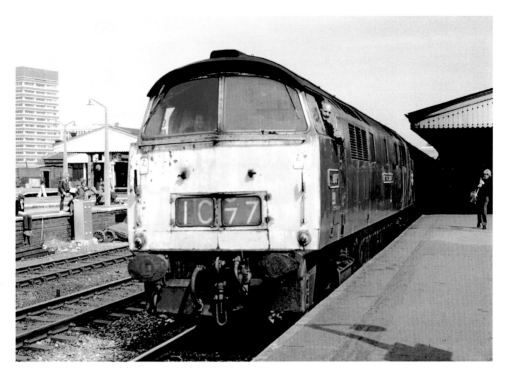

Another cheery view during half term in May 1974 as the driver of D1006 *Western Stalwart* plays up for the gallery on his departure westwards. (Roger Bradley)

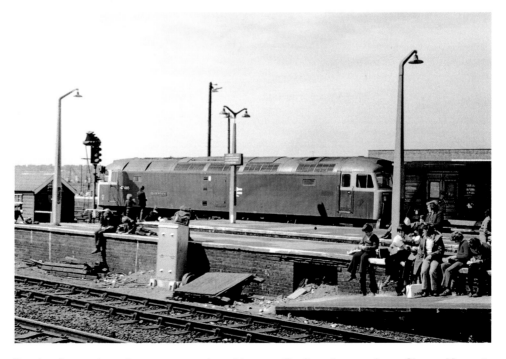

Imagine the reaction today to a scene such as this one at Reading, the same day as Class 47 No. 47085 Mammoth gets away with a parcels working for Swindon and Bristol. Happy days indeed ... (Roger Bradley)

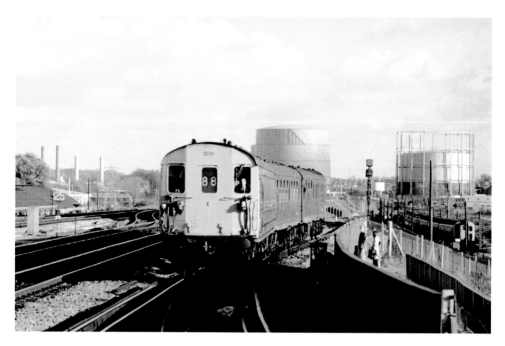

We now take a walk back up to the London end of Reading station in time for a noisy arrival of one of the Tadpole units off the Redhill lines past a stabled CIG unit on the site of the former Southern Region station here on 25 November 1978. (Ian James)

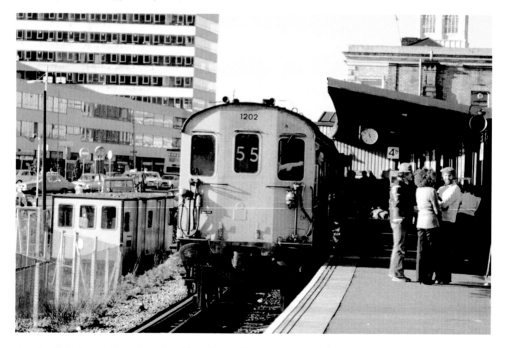

Another Tadpole, this time from the skinny former Hastings unit end. Everyone seems to have time for each other in this sunny early winter photograph. The following years would see Reading expand massively as a town, and likewise many new buildings would surround the station as indeed the station itself would change too. (Ian James)

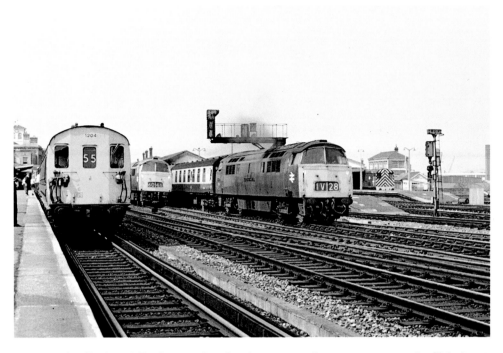

The level of traffic through Reading is reflected in this vista on 2 August 1973 as yet another Tadpole unit awaits departure. An unknown shunter is engaged in the distance, while D1015 *Western Champion* and D1054 *Western Governor* are on the through lines. (Strathwood Library Collection)

A final glimpse back to the Reading of the seventies, frozen in time as well as on the ground with Class 50 No. 50014 arriving, Class 33 No. 33208 departing and a DMU clattering in on 4 January 1977. (Colin Whitbread)